GLOUCESTERSHIRE

Place Names

GLOUCESTERSHIRE
Place Names

Anthony Poulton-Smith

AMBERLEY

First published 2009

Amberley Publishing Plc
Cirencester Road, Chalford,
Stroud, Gloucestershire, GL6 8PE

www.amberley-books.com

ISBN 978 1 84868 721 9

British Library Cataloguing in Publication Data.
A catalogue record for this book is available from the British Library.

Typesetting by Amberley Publishing.
Printed in the UK.

CONTENTS

INTRODUCTION

For years the history of England was based on the Roman occupation. In recent years we have come to realise the influence of the empire did not completely rewrite British history, indeed there was already a thriving culture in England well before the birth of Christ. When the Romans left our shores in the fifth century the arrival of the Anglo-Saxons was thought to herald a time of turmoil, yet they brought the culture and language which forms the basis of modern England. The same is true of our place names, the vast majority of settlement names in Gloucestershire are derived from this Saxon or Old English language, while the topographical features such as rivers and hills still have names given to them by the Celts of the pre-Roman era.

Ostensibly place names are simply descriptions of the location, uses and people who lived there. In the pages that follow an examination of the origins and meanings of the names in Gloucestershire will reveal all. Not only will we see Saxons settlements, but Celtic rivers, Roman roads and even Norman French landlords who have all contributed to the evolution to some degree to the names we are otherwise so familiar with.

Not only are the basic names discussed but also districts, hills, streams, fields, roads, lanes, streets and public houses. Road and street names are normally of more recent derivation, named after those who played a significant role in the development of a town or revealing what existed in the village before the developers moved in. The benefactors who provided housing and employment in the eighteenth and nineteenth centuries are often forgotten, yet their names live on in the name found on the sign at the end of the street and often have a story to tell. Pub names are almost a language of their own. Again they are not named arbitrarily but are based on the history of the place and can open a new window on the history of our towns and villages.

Defining place names of all varieties can give an insight into history which would otherwise be ignored or even lost. In the ensuing pages we shall examine 2,000 plus years of Gloucestershire history. While researching my book *Paranormal Cotswolds* I was delighted by the quintessential English place names around the area and so, having already taken a look at *Oxfordshire Place Names*, turned to Gloucestershire. This book is the result of the the author's long interest in place names which has developed over many years and is the latest in a series which continues to intrigue and surprise.

To all who helped in my research, from the librarians who produced the written word to those who pointed a lost traveller in the right direction, a big thank you.

Chapter One

A

ABLINGTON

From a Saxon personal name with Old English *ing-tun* this name speaks of 'the farmstead associated with a man called Eadbald'. It is recorded as Eadbaldingtun in 855, which shows the perfect Old English form.

ACTON TURVILLE

Recorded as Achetone in 1086, the basic name comes from Old English *ac-tun* or 'the farmstead by the oak trees'. It is possible that some of the Actons across England were named to refer to the wood itself rather than the trees and hence we might find that 'the farmstead where oak timbers are worked' is the correct definition. However without further evidence it is impossible to see the difference.

What is certain is that this is among the many Actons which has a second distinctive element first seen in 1284 as Acton Torvile and referring to the Turville family, lords of this manor from the thirteenth century.

Here is Viners Lane, named after former resident Robert Viner who was here in 1720.

ADLESTROP

Found as Titlestrop in 714 and Tedestrop in 1086, this name is from Old English *throp* preceded by a personal name and thus 'Taetel's outlying farmstead'. The dropping of the first 'T' is not unusual, with the advent of Middle English *atten* (meaning 'at') several names lost or gained a 'T' through confusion between 'a' and 'at'.

Local names include Baywell Wood, 'the wood of spring or stream of a man called Baega; Harcomb Wood, 'the woodland of the valley where harts or stags are seen'; and Conygre Lane, which comes from coninger and tells us there was a 'rabbit warren' here.

ADMINGTON

From a Saxon personal name and Old English *ing-tun*, this name is recorded as Edelmintone in 1086 and means 'the farmstead associated with a man called Athelhelm'.

Locally we find Lark Stoke, a name referring to the 'outlying farmstead frequented by larks'; while Harbour Hill is from *here-beorg* or the 'shelter, lodging hill'.

AKEMAN STREET

This is the name applied to the Fosse Way between Cirencester and Bath. Recorded as Acemannes ceastre in 973, this name appears to have been taken from a place name of 'Akeman's Roman stronghold', however no such place name is known. Without further evidence it is unclear if the place name is an error, or if the second element should be *straet* and refer to the road which has the name Akeman for unknown reasons. It does seem that the name is unlikely to be Roman or even Celtic, indeed it does sound distinctly Saxon and thus the tenth-century record does seem plausible.

ALDERLEY

A place name meaning 'the woodland clearing by the alder trees' is listed as Alrelie in Domesday and derived from the Old English *alor-leah*.

ALDERTON

Recorded as Aldrintone in 1086, this name comes from a personal name suffixed by *ing-tun* and referring to 'the farmstead associated with a man called Ealdhere'.

Minor place names of this parish include Dixton, from Old English *dic-hyll-dun* it describes the 'down of the dike hill'. Hentage is a name used to describe a place where hounds were kept for hunting, what would today be referred to as a kennel; and Dibdins and Dibdins Lane take their name from *dybb-dic*, quite literally 'pool ditch' and referring to where a pool was created as the water channel crossed the lane. Clearly this was not desirable, however the continual passing of wheeled carts made erosion, particularly of wet ground, inevitable.

St Margarets Road and Church Road are named after the church and its dedication, while the Blacksmith Cottages are still in Blacksmith's Road.

ALDSWORTH

In the eleventh century the name is found as Ealdeswyrthe and Aldeswrde, of Old English derivation this is 'Ald's enclosure'.

Minor place names here include Wall Farm, which normally refers to the defensive wall Roman workings. However no such archaeological remains have ever been discovered here, hence the reference is more likely to a boundary bank or similar man-made feature. Lad Barrow refers to the tumulus known as 'the youth's mound'.

Some of the more notable field names here are Ewe Yean Ground, from Old English *eowu-ean* and describing 'the ewe and lamb land' and clearly where sheep were raised. New Tineing marks 'the fenced enclosure'; Pludds Furlong is from Old English *pludde*

and 'pool or puddle'; Slat Quar is an abbreviation of the Saxon *slate-quarriere* or 'the slate quarry'; and Westchestle Furlong marking 'the western heap of stones'.

The local pub is the Sherbourne Arms, named after the Sherbourne Estate. Now a National Trust property it was built in the seventeenth century for John Dutton, a politician who used the Civil War to his advance his political career. Dutton, familiarly known as 'Crump', was renowned for his hunchback.

ALKINGTON

Domesday records this name as Almintune, which is derived from a Saxon term describing 'Alhmund's tun or farmstead'.

Minor names here include Baynham Court or 'Baega's water meadow'; Woodford speaks of 'the ford near the wood'; Cockshute Farm comes from *cocc-siette* telling of 'the glade where woodcock are netted', the birds flushed out by beaters and dogs are considered a delicacy; and Michael Wood is from Old English *micel-wudu* or 'the great wood', although the name is probably best known for the motorway services passed by thousands of cars daily on the M5.

ALMONDSBURY

The personal name here is uncertain as the only record we have of note is from Domesday as Almodesberie. Thus this could be either 'Aethelmod or Aethelmund's stronghold'.

Easter Compton is nothing to do with a religious festival, this name refers to 'the more easterly farmstead by the small valley'. Gaunt's Earthcott is so named as a 'cottage cut from the earth', probably covered with turf, and which it is mentioned in a charter as being on land held by Henry de Gaunt. Patchway is derived from 'Peot's enclosure'.

View of
Almondsbury

ALSTONE

A name recorded in 969 as Aelfsigestun and which speaks of 'the farmstead of a man called Aelfsige'.

The local inn here is the Adam & Eve, a name which has nothing to do with religion in this context but is representative of the arms of the Fruiterers Company.

ALVESTON

With only Domesday's Alwestan as evidence, it is still possible to see this as the '(place at) the boundary stone of a man called Aelfwig'. Here the suffix is Old English *stan*, often confused with *tun* in Domesday's forms.

With the reintroduction of the kite to the uplands of our nation, perhaps this bird will soon be seen once more as it rides the updraughts over Kites Hill.

ALVINGTON

The earliest record of this name is from 1220 as Eluinton, which likely comes from the Old English for 'the farmstead associated with a man called Aelf'.

AMBERLEY

A quite common place name, recorded in Gloucestershire as Unberleia, Omberleia and Amberley in the twelfth and thirteenth centuries. This comes from the Old English *amer-leah* meaning 'the woodland clearing frequented by the bunting or yellowhammer'.

Here we find the Black Horse Inn which, as with the vast majority of coloured animal pub names, is taken from a coat of arms. Unfortunately as the symbol is so widely used, and has been since the fourteenth century, it is virtually impossible to discover the link.

AMPNEY CRUCIS

Domesday records this name as Amenie, which by 1287 is seen as Ameneye Sancte Crucis. Named from the Ampney Brook this is 'the stream of a man called Amma'. The addition, to differentiate from other Ampneys discussed below, refers to the dedication to the church of the Holy Rood. The name has also been taken by the local pub. Once simply the Crown, it took the same addition as the place name and became the Crown of Crucis Hotel.

Around the parish we find minor names such as Ampney Downs 'the expanse of open hill country'; Wiggold 'Wicga's open land'; Little Ackley or 'the smaller oak clearing'; Beggar Hill took its name from being 'the hill frequented by beggars'; Bown's Farm was home to brothers Edward and Thomas Bown in 1756; Dark Quar was 'the dark quarry'; and Hunt's Hill was where Samuell Hunt lived in 1696.

Field names around here can also tell something of the history of the place. Bendons was once 'the bean-growing hill'; Cynderlands comes from Old English *sundor-land* or 'the private or detached lands'; Ponsway features an Old French surname with Old

English *weg* 'the way or ancient street associated with the Ponce family'; Reddington was 'the valley of Read's folk'; and old records of the name of Shoe Croft show it comes from Old English *sceawian* and means 'to look out, examine' and an observation point.

AMPNEY ST MARY

Seen in 1291 as Ammeneye Beate Marie this settlement of 'the stream of a man called Amma' has a church dedicated to St Mary.

Minor place names here include Ashbrook, which refers to the 'land of the east brook' and points to a small tributary of the Ampney Brook. Can Court reminds us of the family of Canne, who held land here during the Middle Ages.

AMPNEY ST PETER

The record of 1275 gives this as Amenel Sancti Petri, the dedication of the church to St Peter being added to the basic name of 'Amma's stream'.

Two Old English minor names here come from *ceorl-hamm* meaning 'the hemmed in land of the peasants' and today seen as Charlham House; and *cu-laes* or 'the cow pastures' and found on the modern maps as Cow Leaze.

ANDOVERSFORD

The earliest record of this name dates from 758 as Onnan ford, which leads to the origin of 'the ford of a man called Anna'.

Pine Halt is a nice name for a new road built on the site of the former railway station. The Kilkeney Inn takes its name from a region which was known as Kilkenny from the eighteenth century, itself a remoteness name, one given to one of the more distant corners of a parish. It is unclear when or how the spelling of Kilkenny (correct in the eighteenth-century record of the place name) became corrupted.

APPERLEY

From Old English *apuldor-leah*, and listed as Apperleg in 1210, this comes from 'the woodland clearing where apples grow'.

The locals drink at the Coal House Inn, the name reminding us that coal was brought down the Severn from Stourport and landed here. The sign depicts the dockers unloading the barge and carrying the heavy sacks to the warehouses.

ARLINGHAM

A name meaning 'the homestead of the family or followers of a man called Eorla' which is recorded as Erlingeham in 1086. This comes from the Saxon personal name with the Old English *inga-ham*.

Priding takes its name from 'the hill where rye grass grows'; Slowwe Farm was given this name for it was situated on 'the mire'; and Friday Street, so often a name leading to the gallows, may also have been simply where fish was sold or distributed.

Still the most common pub name in the country, the Red Lion is a heraldic image and is featured in many coats of arms including Scotland and earlier John of Gaunt.

ARLINGTON

Despite the obvious similarities between this and the previous name, the Saxon personal name involved is quite different. Here the origins are Old English *ing-tun* and describe 'the farmstead associated with a man called Aelfred'. The name is recorded as Alvredintone in Domesday and as Aelfredincgtune at the beginning of the eleventh century.

ASHCHURCH

The only early form of note is as Asschirche in 1287, the name comes from Old English *aesc-cirice* and refers to 'the church by the ash trees'.

Aston on Carrant is a local name referring to its position on the River Carrant and being 'the east tun or farmstead' in relation to Tewkesbury. Other local names include Fiddington, 'the farmstead associated with a man called Fita'; Natton, which was 'the wet farmstead'; Northway or 'the northern enclosure'; while Pamington is 'the farmstead associated with a man called Paefen'.

Home Downs seems to have taken its name from the 'down or open country of Hamon', the individual was probably Robery fitz Hamon, Earl of Gloucester who was granted the manors around Tewkesbury by William II. Possibly a unique etymology is seen in the name of Elmbury, a modern housing estate which is derived from, of all things, a painting! The artist John Moore painted Portrait of Elmbury, a fictitious place which was largely based on Tewkesbury, hence the connection and the reason for the name.

ASHLEWORTH

Found as Esceleesuuorde in Domesday, this Old English place name speaks of 'Aescel's enclosure'.

Close proximity to the River Severn makes the reason for the name of the Boat Inn obvious. Wickridge comes from 'the ridge with a dairy farm'; while Stonebow refers to 'the stone arch bridge' and is the bridge taking the road to neighbouring Hasfield.

ASHLEY

Listed as Esselie in Domesday, this comes from Old English *aesc-leah* and describes 'the woodland clearing of or by the ash trees'.

Here is a field name which perfectly describes Holly Bush Tyning and referring to 'the fence made from holly bushes'.

ASHTON UNDER HILL

Listings of this name include Aesctun in 991 and as Assetun subtus Bredon Hill in the fourteenth century. From Old English *aesc-tun* this is 'the farmstead by the ash trees', with the later record showing the place was beneath Bredon Hill.

Local names include that of Paris, nothing to do with the French capital but a the surname of a family who were here in 1197.

ASTON BLANK

Records of this name include Eastunae in the eleventh century, Aston Magna in 1291, and Aston Blancke in 1685. The basic name here is, as we would expect, 'the eastern farmstead'. The addition at the end of the thirteenth century would have been Latin magna or 'greater', but Old French *blanc* prevailed a word meaning 'white, or bare' and here used to describe a grassless area.

Here we find minor place names such as Camp Farm, the site of a long barrow and associated entrenchments; Hore Stone Ground is named after 'the boundary stone' which once stood here; and Bourton Way is named after 'the road of the dwellers at Bourton on the Water'.

ASTON SUBEDGE

Another basic name referring to 'the eastern farmstead', this example being west of Weston Subedge. The addition refers to this place being situated below the Cotswolds escarpment. The name is found in a document dated 1297 as Aston subtus Egge.

The name of Easter Meadow is clearly associated with that most holy of Christian feasts, but just how it was connected is unknown. There were a number of local rites associated with Easter, some of which have been revived in the present era — the practice of cheese rolling, for example.

AUST

Listed as Austan in 794, this is one of the very few place names in England which comes directly from the Roman occupation of England. Indeed such examples are so rare, and the record we have so late after the departure of the empire, it is difficult to understand the origins. This could refer to Latin Augustinus, a Roman personal name which, if it is the basis for the place name, would require further evidence to support the claim and no record of any significant deeds by a man of this name is recorded. Because no record has been found the second explanation is more often cited, where the basis is Augusta. It is thought to allude to the crossing of the River Severn used by the Roman Second Legion, evidence for this does exist.

AVENING

Records of this name have been found as Aefeningum in 896 and Aveninge in 1086. Here the basis is the Celtic river name Avon (meaning simply 'river') and the Old English *ingas*, which together speak of 'the settlement of the people living near the Avon'.

Interesting minor names found here include Brandhouse Farm from *brende-hus* or 'the burnt house'; Rackley Barn was associated with Elizabeth Rackley in 1805; Enox is a field name from Middle English *in-hoke* and 'land temporarily enclosed from fallow land and cultivated'; and the delightful name of the Tingle Stone, seen as a long barrow with a stone on top and which comes from Middle English *tingel* meaning 'a nail' and from a root word teng 'fastening', thus this name describes it as the stone covering the entrance.

Two pubs here, both of which have connections with the church. The Cross Inn reflects the dedication of the Church of the Holy Cross, while the bell is a common name showing the simplest and most easily recognised link to Christianity and is here given a unique addition in the name of the Bell at Avening.

AVON (RIVER)

This old Celtic river name is found several times in England, all of which date back to the era before the Roman arrival and can still be seen in the Welsh *affon*, which also means 'river'. Often such definitions are given as overly simplistic, for the vast majority of Celtic river names have meanings such as 'river, water, fast, dark, etc'. However even today the local river, especially when it is more than a brook or stream, is rarely referred to by name but merely as 'the river'. In the days when the local river may well have been the only sizable watercourse most people would see, 'the river' would be more than an adequate name for it.

Gloucestershire has three significant rivers of this name, all of which are tributaries of the Severn. That which joins the Severn at Tewkesbury is also known as the Warwickshire Avon and the present river course is artificial, having been created to provide water for the mill. The old river bed still has water in it and is known as the Old Avon. Records of this river start in 704 as Afen, with later records of Afene 922, Auena 1100, and Avena in 1135.

We also have what is known as the Bristol Avon, which predictably joins the Severn at Bristol and is recorded as Abone in 793, Aben 796, Afene Stream 883, Avon 1634 and the Bristol Avon for the first time in 1779. Finally the Little Avon River, which empties into the larger river at Berkeley and is found as On Afene in 972, Avon in 1540, Le Haven in 1575, Aven fluuiolus in 1590, the Berkeley Avon in 1779, and the Little Avon River for the first time in 1830.

AWRE

Listed in Domesday as Avre, this probably comes from the Old English *alor*, meaning the '(place at) the alder tree'.

Local names include Blakeney, 'the black or dark island'; Bledisloe, 'the mound

associated with a man named Blith'; Etloe was once 'Eata's mound'; Hagloe was the 'hill where haws grew'; and the 'gap valley' is today known as Gatcombe.

AYLBURTON

The earliest record of this name comes from the twelfth century as Ailbricton. This seems to come from the Old English tongue brought to our shores by the Saxons and refer to 'Aethelbeorht's farmstead'.

 Named after the king, the local is the George Inn. However there is no regnal number and, as the image is not recognisable, it is difficult to know which King George the name refers to. The likeness best resembles George III and the dress certainly fits the period, yet it seems most likely to have originally been the first King George for, when he was on the throne (1714-27), he had no regnal number. Later reigns saw three more Georges on the throne, indeed King George would have been relevant until 1830 and included the sixty years of George III, the longest reign of any English king.

Chapter Two

B

BADGEWORTH

Listed as Beganwurthan in 862 and Beiewrda in 1086, this comes from the Old English and tells us of 'Baecga's enclosure'.

Bentham is a commonplace name which refers to 'the homestead near the bent grass', while The Reddings comes from Middle English *rydding* meaning 'clearing'. Crickley features British or Celtic *crouco* or 'hill' followed by Old English *leah* and referring to 'the woodland clearing' — together they refer to the ancient earthwork.

The name of the Devil's Table is one of those 'devil' place names which never refer to Satan directly. This reminds us that in times past to attend church on a Sunday was compulsory, those who failed to attend were assumed to have been up to no good and were fined accordingly. Thus this region will have been associated with people who were continual absentees at the place of worship on the Sabbath.

BADMINTON

An Old English place name from 'the farmstead associated with a man called Baduhelm'. Records of this name include Badimyncgtun in 972 and Madmitune in 1086.

BAGENDON

A place name recorded as Benwedene in Domesday and as Baggingeden in 1220, this later record being the more accurate. Here is a Saxon personal name followed by Old English *inga-denu* and meaning the '(place in) the valley of the family or followers of a man called Baecga'.

Minor names here include Burcombe Lane, from Old English *bur-cumb* or 'the barn valley'; Pewt's Copse, an Early Modern English *puwit* and referring to the '(place of) the peewit', also known as the Northern Lapwing; Hitchings is a field name from Old English *heccing* and telling us it was 'that part of the field which is sown'; and Football Close, of obvious origins but was interestingly recorded as such in 1792, an early football venue.

BARNSLEY

An Old English place name found as Bearmodeslea in 802 and Berneslei in 1086, it refers to this being 'Beornmod's woodland clearing'.

Within this parish are found the names of Poultmoor, which may be a combination of Old French *pount* and Old English *mor* describing 'the bridge of or at the marsh'. Alternatively the first element may be a personal name, such as *Pulta* or *Punta*. Winterwell is a stream name, from Old English *winter-wella* and describing the 'stream which could only be relied upon in winter'. Often such names are said to be 'the stream which only flows in winter', yet there is no logic in this for, as any resident of islands will be aware, all that is predictable about the English climate is its unpredictability.

Field names in and around Barnsley include Catsbrain, a name only found here and in neighbouring Oxfordshire, it is always from Old English *cattes-brazen* and referring to the 'soil of clay mixed with gravelly stones'. Forehead is an unusual field name which comes from Old English *fore-geard* and meaning 'the front yard or enclosure'. Old English *launde* is shown on modern maps as The Lawn and points to the 'glade, woodland pasture'. Penny lands marks where strips of land on common land were renting out for a penny rent; while Portway Piece is the land alongside Akeman Street.

The local tavern took a simple and highly accurate name, calling itself the Village Inn.

BARNWOOD

Domesday records the name as Berneuude and, while it is certainly derived from Old English *beorn-wudu*, it is unclear if this is 'the wood of the warriors' or if this is a personal name as 'Beorna's wood'.

Lobleys Farm is a name which delights the author for defining it gives an idea of the way the place looked in Saxon times, for this is the '(place of) the low hanging branches' and is something which even archaeologists would find difficult to show.

BARRINGTON

Actually three names Barrington, Great Barrington and Little Barrington are shown on the map — the civil parish, and two villages separated by the River Windrush. Domesday shows just one name of Bernintone, which points to this being 'the farmstead associated with a man called Beorna' with the personal name being followed by the Old English elements *ing-tun*.

Field names of note in Little Barrington are the Byres, telling us of a place where there were 'cow sheds', while the name of the Hitching is from Old English *heccing* and where only 'part of the field was sown'.

BARTON

A common place name which comes from Old English *bere-tun* and referring to 'the barley farm'. This example near Guiting is listed as Berton in 1158.

BATSFORD

Found as Baeccesore and Beceshore in 727 and 1086 respectively, this is 'the hill slope of a man called Baecci' with the personal name followed by the Old English element *ora*.

Locally are the names of: Blenheim, named as such from 1830 and named after the Battle of Blenheim, a major engagement of the Spanish War of Succession fought in 1704; Boram Farm was known as 'the boar meadow'; Cadley Hill was first seen in 1630 and is 'Cado's hlaw or mound'; and Monka Meadow, named for it was held by the monks of Tewkesbury Abbey.

BAUNTON

Domesday is the only record of this name of note, as Baundintone in 1086. Here the Saxon personal name is followed by the Old English *ing-tun* and describes 'the farmstead associated with a man called Balda'.

Here we find Dentice Bushes, which features a local surname with Old English *busc* or 'Dainty's bushes'; Lynch Brake, from Old English *hlinc* and referring to a 'ridge, an unploughed strip between cultivated parts of a field or fields'; while Shooters Clive comes from *sceotere-clif* or 'the cliff of the shooters or archers'.

BEACHLEY

Not found until the twelfth century, as Beteslega, this is an Old English name telling us it began life as 'the woodland clearing of a man called Betti'.

BECKFORD

Listed as Beccanford in 803 and as Beggeford in 1166, this is 'Becca's ford'. Within this parish are the names of Didcot Farm, from 'Dyda's cottages', and Saberton from Old English *sapere-tun* and describing 'the soap boiler farm', a place where soap was produced on a commercial scale and not just for personal use.

BENTHAM

From Old English *beonet-ham*, and listed as Benetham in 1220, this name means 'the homestead where the bent grass grows'. Place names are coined because of the region, are often a description of the region, and must exist for some time in order for the name to stick. Clearly grass will never grow bent, but will eventually collapse if not cut or grazed due to wind or rain. This does not explain why the grass collapsed, but does show this area was not grazed, either by wild animals or livestock, and that the settlement were unlikely to be farmers.

BERKELEY

Listed as Berclea in 824 and Berchelai in 1086, this is from the Old English *beorc-leah* and describes 'the woodland clearing in or by the birch trees'.

The George public house was built as the George & Dragon in 1840, the original name a reference to the patron saint of England and the modern name simply how it had always been described by the regulars. The Berkeley Arms is self-explanatory, as is Market Place and the name of High Street, not the most elevated but the most important. Salt House was owned by a salt merchant in the 1820s, the name was later taken by Salter Street. Merchant John Day was also a renowned ship owner, his house lies beside the Pill (a tidal creek) from the days when the town was also a port. Stock Lane was originally known as the 'stock', after the wooden frame upon which a ship was built up.

Jumpers Lane is also thought to be a reference to the former port. The only time the Pill was at high water and, being pulled by hand, this was achieved by jumping the boat forward at each successive high tide. The Mariners Arms Inn is another reminder of the town's historical connection with sea-faring and shipping.

The Chantry is a house which now describes itself as the Jenner Museum, Edward Jenner being known as the father of immunisation for his work on smallpox. Less famously is his paper written and presented to the Royal Society in 1788, in which he described the lifecycle of the cuckoo. Today that this bird lays its eggs in the nests of others is known to all, however when Jenner put forward this information at the end of the eighteenth century it was refuted. Indeed cuckoos were thought to raise their own young for over a century afterwards, until the dawn of the age of photography. Jenner Court was also named in the man's honour.

Hickes's Row takes its name from either Mr Hickes of the monastery of St Austria who owned a house here in the sixteenth century, or from the Mr Hickes who lived in Canterbury Street in the sixteenth century, although there is no suggestion that the two men were in any way related. In earlier times the place was known by the locals as Sooty Bags Alley, an unofficial name which probably referred to the chimney sweep who once lived here.

Frying Pan Alley led to Lamb Court, itself taking the name of the Lamb Inn, where seven cottages and two wash houses were found. Together the court and the alley form the shape of a frying pan, hence the name. The Lamb Inn was later Tom Warren's butcher's shop and then a restaurant and lodging house belonging to Mrs Williams. Lynch Road takes its name from the landscape, the feature known to the Saxons as *hlinc* referred to the 'bank or ridge'.

Coach Close was named after coach operator Percy Stump, who also ran a feel of private taxis. Avery Green was owned by Robert Avery around 1300, while James Orchard is a newer housing estate on land once occupied by a cider mill belonging to the James family.

Three public houses in Berkeley, the Salmon Inn reflects the target of fishermen in the Severn to the west, the Stagecoach Inn was a stopping point when it was the way to travel the roads of England, and the Boars Head Inn commemorates Christmas and the days when the head of a boar (complete with apple in the mouth) formed the centrepiece at the table of the larger establishments.

BEVERSTONE

Meaning 'the boundary stone of a man called Beofor', this place is listed in Domesday as Beurestane.

Haine's Sleight is a field name which tells us it was 'Haine's sheep pasture'.

BIBURY

A place name recorded as early as the eighth century and again in Domesday, as Beaganbyrig and Begeberie respectively, there is more information on this place name on record than is normally found, especially considering it dates from over thirteen centuries ago. The name speaks of 'the fortified manor house of a woman called Beage', which is confirmed in a document showing that Beage leased the estate from 718 to 745.

Within this parish we find Ablington, 'the farmstead associated with Eadbald'; the similar Arlington or 'the farmstead associated with Aelfred'; Deanhill, from Old English *denu-hyll* or 'the valley near the hill'; Gambra Hill, recorded as Kanbarrow in 1840, is the' hill barrow or tumulus'; and Lambrough Banks from Old English *lang-beorg* or 'the long barrow'.

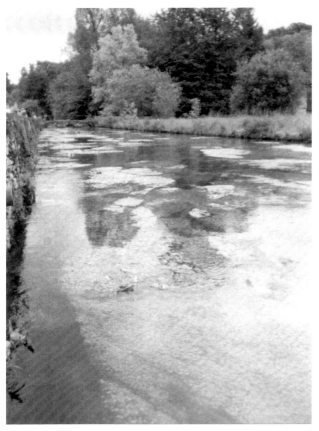

The River Coln at Bibury

Field names include Cunninger from Old English *coninger* 'the rabbit warren'; Hand Post Ground takes its name from the guide post marked on maps as the Hand and Post in 1768; Lagger Hill features a dialect term *lagger* meaning 'a narrow strip of land or a copse uniting two otherwise separate parts of a farm'; and The Lains is from Old English *leyne* or 'the tract of arable land'.

Here is a pub called the Catherine Wheel, a name which immediately brings to mind the firework which has spun rapidly on many a fence post for as long as anyone can remember. It is named after St Catherine of Alexandria, who is said to have been martyred by being tied to a larger version and spun rapidly until death. While the sign will often depict the firework, the real origin of the pub name comes from the Knights of St Catherine of Mount Sinai, an order who used the symbol as their badge and offered protection to pilgrims on their journey to Jerusalem. Hence early use as a pub name suggested a safe haven for travellers.

BIRDLIP

First seen in 1221 as Bridelepe, the name comes from Old English *bridd-hlep*. This speaks of the '(place at) the steep region of land frequented by birds'. This probably suggests the birds were providing a regular source of food for the inhabitants.

The Air Balloon Inn was a popular name from the time when brothers Joseph-Michel and Jacques-Etienne Montgolfier were the talk of the town for having designed the

Road sign at Birdlip

world's first successful hot air balloon. On 21 November 1783 the first manned flight took place, lasting twenty-five minutes it travelled a distance of just over five miles. An earlier test flight saw a sheep, who went by the name of Montauciel meaning 'climb to the sky', a rooster and a duck carried aloft. What is less well known is that the famous ballooning pioneers never left the ground in any of their constructions, the first flight being made by physicist Jean-Francois Pilatre de Rozier and army officer François Laurent d'Arlandes.

BISHOPS CLEEVE

Records of this place go back to the eighth century as Clife, with Clive in 1086 and Bissopes Clive in 1284. The basic name comes from Old English *clife* and referring to the '(place at) the cliff or bank', while the later addition shows possession by the Bishops of Worcester.

Voxwell is a corruption of Old English *fox-wella*, 'the spring or stream where foxes are seen'.

Local pubs include the Royal Oak, the second most common pub name in England and one which shows the image of the famous oak tree in which Charles II and his aide Colonel Carless his to escape Roundhead soldiers after the Battle of Worcester in 1651. The tree in question is located at Shifnal in Shropshire, and is probably the most painted tree in British, if not world, history.

The Old Farmers Arms is a welcoming sign, an offer to the most likely customer in a principally rural community. Simple visual imagery was popular for it not only was cheap to reproduce but was easily recognised and understood. With the Crown and Harp a proprietor or landlord showed allegiance to the monarchy and also to Ireland, albeit the latter by depicting a Welsh harp.

BISLEY

A name found in the tenth century as Bislege and in the eleventh as Biselege, which seems to originate in the Old English describing 'Bisa's woodland clearing'.

Many minor place names of note here including Battlescombe, not the scene of a dispute but a personal name in 'Baeddel's valley'. The name of Dagnish Wood unites the Old English elements *tagga* and *ecg* to tell us it was 'the escarpment or edge where young sheep are raised'. Daneway comes from *denu-weg* and 'the road through the valley'. Frith Farm and Frith Wood feature the element *fyrthe* meaning 'well wooded'. Litteridge Wood tells us it was once simply 'Lutta's ridge'. Middle Lypiatt features a fairly common minor name, from Old English *hliep-geat* and showing there was a 'leap gate' here, 'a gate in an enclosure fence which was low enough to let deer leap over but high enough to bar the livestock from escaping'.

Stean Bridge comes from 'Steven's Bridge'; Througham is from 'conduit' and a ditch dug to bring fresh water in to the area or possibly sewage or excess water away of here. Tunley is among the simplest of Saxon place names, from Old English *tun-leah* or 'the farmstead in the woodland clearing'. Wittantree comes from Old English *witena-treow* literally 'the tree of the councillors' and telling us it was a meeting place for local representatives on a regular basis.

Jaynes Court takes the name of a resident named Janes, a Middle English variation on the surname Johns. The name of Kitlye tells us it was 'the glade where kites are seen', this refers to the bird, today a rare site indeed in the skies of Gloucestershire. Piedmont is a remoteness name, although it is difficult to understand where it comes from for as Piedmont the name is found in several places in Canada and the USA, however Montpied is a name found in France. The reversal of the elements is to be expected between French and English.

Siccaridge Wood tells us it was known as 'the safe or secure ridge'. The Snubbs has a name meaning 'to check the growth, nip out the growing tip' and from this we can deduce it was where some plant was grown to be sold on, or perhaps a kitchen garden. Handkerchief Ground is a name which describes a very small plot, likely a derogatory name. Similarly there is the name of Pest House, a name which would not be acceptable today and yet historically it was used differently and only referred to 'the house for those with infectious diseases'.

Public houses of Bisley include the Stirrup Cup Inn, which is associated with the drink offered to the master of the hunt by the landlord of the pub where the huntsmen met. However the origins are much earlier than this and refers to the drink offered to any rider before they rode off, the equivalent of 'one for the road'.

A bear is easily recognised and has a number of potential origins when applied to the Bear Inn. Most are preceded by a colour and thus are heraldic. Others could have been an advertisement for the place being home to bear-baiting sessions, a blood sport which involved chaining the bear to posts and setting dogs upon them. This barbarism was finally banned in 1835, although a shortage of bears had already made it a comparative rarity. In recent years a third possibility has grown in popularity, where it has been suggested that the image of the bear is a more recent development and the original sign was simply an advertisement for 'beer' but spelled wrongly. This explanation would be more acceptable if 'beer' had been in use far earlier, when in reality it was referred to as 'ale'.

BITTON

Despite the sole record of note being Domesday's Betune, the origin of this name is still clear. This is clearly 'the farmstead on the River Boyd', where the suffix is Old English *tun*, the origin of the Celtic river name is discussed under its own entry.

Three local names of note, Bullhall Farm stands on the region which was simply 'the enclosures for bulls', Beach refers to 'the beech tree' not a sandy embankment as the spelling suggests, while Weston Court was once the home of Nicholas de Weston.

BLADEN (RIVER)

Listed in 695 as Bladon and in 718 as On Bleadene this is not a typical river name and is an example of back-formation. It is not unusual to find a place name being taken from the nearby river, however in antiquity there must have been cases where the place name was misunderstood as having come from the river when the reverse was the case, indeed the eighth-century record here of On Bleadene 'on the Bladen' shows this was the case in this example.

Here the etymology of the name becomes a little more complex, for the place name in question is Bladon in Oxfordshire and, when we examine the etymology of this place name, find it to be an old name for the River Evenlode on which it stands. The Evenlode takes its name from the Gloucestershire village, another example of back-formation, while the Baldeon is thought to represent an ancient British name for the river. These British languages and dialects had no written form and we only know of them through association with their daughter tongues which evolved from them. Thus the meaning of Bladon or Bladen is unknown as a river name. Of course it is always possible that this represents another case of back-formation, where another place name of Bladen gave its name to the river. However we have no records of any such place name, which is not surprising for it could have stood anywhere along or near its length.

It seems that, unless further evidence is uncovered, the origins of this river name will remain a mystery.

BLAISDON

Here is a place name meaning '(place at) the hill of a man called Blaecci', with the suffix from Old English *dun*. The earliest surviving record is from 1186 as Blechedon.

BLAKENEY

Recorded as Blakeneia in 1196, this place name comes from Old English *blaec-eg* and describes 'the dark-coloured island in the marsh'.

BLEDINGTON

Domesday's Bladintun is of little assistance in defining this name. Clearly this is Old English *tun* or 'farmstead', while the first element refers to the River Bladon an old name of the River Evenlode and one which has defied definition.

The name of Woodenham takes its name from 'Woda's water meadow'; while the field name of Quickham tells of how there was 'a quickset hedge of or by the water meadow'.

BLOCKLEY

'Blocca's woodland clearing' was listed as Bloccanleah in 855 and Blochelei in 1086.

Dorn comes from Celtic *duro* and means 'gated'; Paxford takes its name from Paecc's ford and crosses the Knee Brook here; Upton Wold Farm is from Old English *upp-tun-wald* and 'the upper famrstead of the hill'. The name of Ditchford on Fosse is named from the 'dike ford', here where the Fosse Way crosses the Paddle Brook or Knee Brook, although Old English *dic* and Latin *fossa* both mean 'ditch'.

Here is the Great Western Arms, a public house named to remember the Great Western Railway designed by arguably the greatest all the nineteenth-century engineers Isambard Kingdom Brunel. By the time the country had a unified railway system the

standard gauge of 4 feet 8½ inches had replaced Brunel's Great Western broad gauge of 7 feet and ¼ inch. Certainly the broader gauge made for bigger engines, thus heavier trains and more powerful engines, and it was only because of the many more miles of track, and numbers of engines and rolling stock which meant the broad gauge was the one to give way. Incidentally the choice of 4 feet 8 ½ inches was not arbitrary, nor was it chosen using any mathematical or scientific method or even, as legend has often quoted, based on the distance between the wheels of Roman chariots. It was simply the gauge employed for the horse-drawn wagons which ran close to George Stephenson's home. Hence it was pure chance, for no two horse-drawn railways had exactly the same gauge.

BODDINGTON

Domesday's record of Botingue is the only clue we have to defining this name. However it seems this is 'the farmstead associated with a man called Bota'.

What is known as Withy Bridge tells us it was once said to be 'the bridge near the willows'; Brooklaines Farm began life as 'the brook near the arable strip of lane'; Throck Acre is derived from Middle English *drock* or 'the covered drain'; and there is nothing sinister about the name of Dead Furlong, it is simply telling us it was 'disused'. Former residents gave their names to Mordon's Wood, the family of Mordaunt were here for a number of generations around the fourteenth century, the same time as Philip Boteler was recorded here and who gave his name to Butler's Court.

BOURTON ON THE HILL

A name found in Domesday as Bortune and as Bourton in 1195. This name refers to 'the fortified farmstead' with the addition to distinguish it from the following entry.

Slate Barn is not named for its roof but from Old English *slaeget* or 'sheep pasture'; while Blindwell Furlong marks the spot of the 'hidden well'.

Field names around here are named after the families who owned or rented them during the nineteenth century. Hence we find Brooke's Allotments, Boswell Allotments, Hull's Meadow, Marshall's Meadow, Tomb's Meadow, Smith's Mill, Sharp's Lake, Mince's Marsh, Goffe's Allotments, Ingram's Allotments, Mary Collett's Allotment, and Robert Fosse's Grounds. There is also Nicholl's Barrel, the Nicholl family owning the land where a spring flowed all year round, never running dry even in summer months, hence the term 'Barrel'.

BOURTON ON THE WATER

From Old English *burh-tun* the basic name refers to 'the farmstead near a fortification'. It is recorded as Burchtun in 714 and Bortune in 1086, the addition is a relatively recent one and refers to the River Windrush which famously flows through the village.

Looking at the map we find names such as: Nethercote, 'the lower cottages'; Ryphan, a name given to 'the rough meadow'; Blindwell takes its name from a 'secluded well or spring'; Tagmoor Farm refers to the 'moor of the *taegga* or young sheep'; and

Salmonsbury, nothing to do with the game fish but a large rectangular encampment from *sulh-man* or 'ploughman' and telling us it was where he kept his team of oxen.

Two pubs of Bourton have names taken from two very different areas. The Duke of Wellington honours one of our nation's best-known military leaders, famous for his victory over Napoleon at the Battle of Waterloo. Less well known is that he also served as prime minister and that the title chosen by Arthur Wellesley, as he was born, is a village in Somerset — a strange choice for an Irishman. The second pub is the Kingsbridge, a name of very local origins and referring to the crossing over the Windrush on land which was under the control of the Crown.

BOX

A simple name with a simple origin. As with the Old English *box* it refers to the '(place at) the box tree' and is recorded as la Boxe in 1260.

BOYD (RIVER)

A tributary of the Bristol Avon which has a number of potential origin theories, but they remain theories for the British language from which they come is unrecorded and we can only associate the forms with surviving languages such as Welsh, Breton, Cornish, or Gaelic. The river is found in 950 as And land byd (literally 'land by the Boyd') as On bydyncel in 972 ('place on the Boyd') and in the modern form by 1712. We also find small stretches of the river noted as the Old Boyd and Little Boyd, which have no etymological value but do show where the river was diverted to power a watermill.

Suggestions as to the origin of the name are all found in the Welsh tongue. Hence the name could be related to *budr* 'dirty' or *baw* 'dirt' and describing a river which does carry sediment. Alternatively this could be another reference to the watermills which stood along the banks, thus possibly represents something akin to *budd* meaning 'profit, benefit'.

BRADLEY STOKE

Here are two of the most common place names in combination. Bradley is from Old English *brad-leah* or 'the broad woodland clearing' and *stoc* in this instance refers to 'the outlying place'.

BREADSTONE

The earliest records come from the thirteenhth century, as Bradelestan and Bradeneston. Undoubtedly this comes from Old English *brad-stan* and speaks of the '(place at) the broad stone'.

Billow Farm and Billow Brook take their name from Old English *beo-leah* or 'the woodland glade frequented by bees'. It is likely that the name of the farm precedes that of the brook.

BRIMPSFIELD

The unusual development of this place name has produced the fairly recent 'p' in the name, probably more through local pronunciation than the normal development. Listed in Domesday as Brimesfelde, this name means 'the open land of a man called Breme'.

BRISTOL

Today the city is not a part of Gloucestershire but for the vast majority of the existence of the county it has been. As the Saxons were instrumental in the creation of the counties and it is their language which has given us most of the place names we see today, the historic port demands inclusion.

The earliest records of this name date from the eleventh century, as Brycg stowe before the arrival of the Normans, and as Bristou in the Domesday record which had been ordered by William the Conqueror in Gloucester Cathedral on Christmas Day 1085. This name comes from the Old English *brycg-stow* and refers to 'the assembly place by the bridge'.

Bristol's Wharfland

Streets of this famous city remember the earlier people otherwise long forgotten and places which would otherwise be unrecognisable for they are covered by the modern world of concrete. Baldwin Street recalls landholder Baldewin Albus who was here in 1160. Canynge Street would not be recognised by the family named Canning, who were wealthy merchants dealing in cloth, it is pleasing to find the street name has retained the early spelling of the family's name. Counterslip is a combination of Old English *hleap*, quite literally 'leap' and referring to where wild animals such as deer could clear a fence which would contain livestock, with 'countess' and showing an association with a Countess of Gloucester.

Small Street is actually referring to the 'narrow street', Wine Street was home to numerous taverns and probably sought out for the number of wines available from around the world, Brandon Hill took the name of the church on St Brandon's Hill, Knowle is from Old English *cnoll* or 'hillock', Addercliff speaks of 'the bank or cliff where adders were found', and Lawrence Hill took the name of the Hospital of St Lawrence which was here by 1779.

Public houses around Bristol have, somewhat predictably, reflected its maritime tradition with names such as the Ship Inn, Portwall Tavern is in Portwall Lane and a name of obvious origins, the Old Fish Market does indeed occupy part of the building where fishermen auctioned off their catch,

The Pitcher & Piano is a modern pub name, created as it fills the two basic criteria in alliteration and two completely unrelated items. The Greenhouse, which is actually painted blue, is known as such because of the amount of glass in the front of the building. The Rummer Hotel features a word from the Dutch *roemer* and is a large glass which would never have contained rum. The Walkabout Inn is a welcoming name, as is the Apple Cider Inn which also advertises the product as does both the Orchard Inn and the Bunch of Grapes. The Artichoke is simply an easily recognised shape and easy to show on the sign, as is the Bell, the Bay Horse, and Ostrich Inn.

Heraldic reminders are found in the White Hart Inn, the White Lion, while the Three Tuns is a part of the arms of both the Worshipful Company of Vinters and the Worshipful Company of Brewers. Well known figures in history include the Shakespeare, the Reckless Engineer reminds us of Isambard Kingdom Brunel, and the Knights Templar remember the famous fighting monks.

BROAD CAMPDEN

Listed as Bradecampedene in 1224, this name speaks of 'the broad valley of the enclosures' and is derived from Old English *brad-camp-denu*.

BROADWELL

Listed as Bradewelle in Domesday and from Old English *brad-wella*, this is one of several place names which describe 'the broad stream'.

Three local names of note: Cauldwell Brook is 'the cold spring'; Cownham comes from 'the water meadow where cows are grazed'; and Fitmoor Meadow is derived from Old English *fitt-mor* and thus 'the moorland subject to dispute'.

Regulars at the Bird in Hand will have seen a sign which shows a falconer with the hunting bird on his arm. However this is simply because it is easier to depict than the message of 'The bird in the hand is worth two in a bush', itself hoped to tempt prospective patrons to sample their wares.

BROCKHAMPTON

This place near Severnhampton is derived from the Old English *broc-ham-tun*, or 'the homestead by the brook'. It is first recorded in 1166 as Brochamtone.

BROCKWEIR

Not surprisingly this place name is from Old English *broc-wer* and means 'the weir of the brook'. It is first listed in the twelfth century as Brocwere.

BROCKWORTH

The earliest record is as Brocowardinge in Domesday. Here the two Old English elements *broc-worthign* come together to describe 'the enclosure by the brook'.

Castle Hill is a place name referring to the encampment on Cooper's Hill. Droys Court takes its name from the family of Drois, the Droys estate being recorded from the twelfth century.

BROMSBERROW

Domesday records this name as Brummeberge, with listings of Bremeberga in 1166, and Bromesberga in 1180. From Old English *brom-beorg* this is 'the broom covered hill'.

Aubreys is a region named after the family of Thomas Aubrey, here in 1424.

BROOKTHORPE

Old English broc-throp had become Brostorp in Domesday and Brocthorp by the twelfth century, all showing this was describing 'the outlying farmstead by a brook'.

Funnels Farm takes its name from its location near the 'ferny hill', while Ongers Green tells us it was 'the wooded slope'.

The Four Mile House is named because it stands opposite the mile post showing four miles to Gloucester. The Glocester Flying Machine took the name of the stagecoach service which stopped here during the eighteenth century. Thrice weekly the coach plied the 105-mile route between Gloucester and London, it was pulled by six horses and claimed it was an unbeatable express service by covering the journey in just two days. It is odd that the spelling of the pub name, and of the coach, has not evolved along with the names of both the city and the county.

BUCKLE STREET

The road of this name runs between West Subedge north to Bidford on Avon in Warwickshire, a distance of some seven miles. Records of this straight Roman road include Buggilde Stret in 709 and Bugkildweie in 1248, which features the female Saxon personal name Bughhild. We have no idea who this person was, and doubtless never will, yet it is fairly safe to say she was living at a small farming community somewhere along the length of the road.

BULLEY

It is not surprising to find this name comes from Old English *bula-leah* or 'the woodland clearing where bulls graze'. It is recorded in Domesday as Bulelege.

Chapter Three

C

CAINSCROSS

An odd name which, despite not being seen before 1776, is difficult to define. It seems this must have been a 'crossroads associated with someone called Cain', however although the crossroads is clear, there is no record of anyone of that name being around here.

Saxon personal name are evident here with 'Dudda's bridge' and 'Eadbald's woodland clearing' appearing on modern maps as Dudbridge and Ebley respectively.

CALMSDEN

Recorded as Kalemundesdene in 852, this name features the Old English suffix *denu* and speaks of 'the valley of a man named Calumund'.

CAM

A place name listed in Domesday as Camma, it is derived from the River Cam here, itself an old Celtic name meaning 'crooked'.

Ashmead Green comes from 'the meadow with an ash tree'; Clingre House is from *claeg-hanga* or 'the clayey wooded slope'; Hengaston Farm features three elements, hen or 'water hen' and *gaers-tun* 'the pasture farm'; Crapon Field is actually a personal name, either Crispin or Crepun; Hocker's Hill recalls Jone Hoker, here in 1608; King's Hill could refer to Richard King or John King, here in 1593 and 1702 respectively; and Tait's Hill reminds us that the Tayte family were living here in 1692.

A family which can trace an unbroken history since Saxon times merits having the Berkeley Arms named after them, while the Railway Inn was opened shortly after trains first stopped at the newly opened station.

CAMBRIDGE

A place name not far from the above and, with the addition from Old English *brycg*, speaks of the '(place at) the bridge over the crooked river'.

Carrant Brook

CARRANT BROOK

A tributary of the Avon which flows to Tewkesbury and is listed as Rivuli Carent in 779, Karente in 1274, Karentam in 1318, Caraunt in 1482, and Carrants Brooke in 1626. One of the delights in defining river name is in finding comparable river names elsewhere in Europe and across the Indian sub-continent. This is further evidence of the origins of the vast majority of the languages native to these regions, evolving from a Proto-Indo-European which is said to existed anywhere from 6,000 up to 12,000 years ago depending upon the school of thought. Similar river names are seen in Europea with Charente and Karantona, both from the Celtic *carant* and related to Welsh *car*, 'friend', and referring to the 'friendly or pleasant stream'.

CERNEY

Three places of this name, all within 10 miles of each other, North Cerney and South Cerney are at opposing points on the outskirts of Cirencester and named for that reason, while Cerney Wick is further south still and includes Old English *wic* of 'specialised farm'. The name of Cerney comes from two elements, the River Churn is a Celtic river name and combines with Old English *ea* meaning 'stream'.

Right: Cerney Canal

Below: Cerney Wick signpost

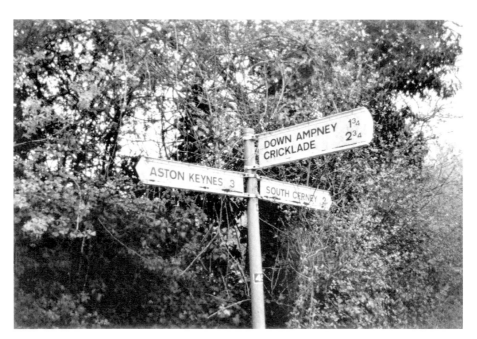

At Cerney Wick are a number of minor names of Old English origin, including Hailstone Bridge, or *halig-stan* referring to 'the holy stone' and likely a stopping place on the annual rite of blessing (or beating) the boundaries to ensure a bounteous crop, what began as a pagan ritual was adopted by Christian worshipers. Boxwell Springs comes from 'the stream of the box trees'; Clark's Hay was the 'haeg or enclosure of the Clark family'; Packer's Lease began life as 'Packer's *laes* or pasture'; Gretton is from *graed-tun* or 'the farmstead of stubble'; Hussey ham is a field name first seen in the seventeenth century and referring to 'the hemmed in land of the housewives'; and Tween eyes is recorded in 1653 and describing 'the land between the streams'.

The Old George Inn is a seventeenth century coaching inn which was named for the first King George of the House of Hanover and for the name also being used for the following three kings.

CHACELEY

Found in 972 as Ceatewesleah, this is most likely a combination of Celtic *ced* or 'wood' with Old English *leah* meaning 'woodland clearing'. Obviously the Celtic name had existed for some time and was not understood by the Saxons when they added their suffix.

Hawker's Farm might be said to represent a place once associated with a 'hawker' or 'falconer'; however it is more likely that Hawker is a surname.

The local pub is the Old Ferry Inn, an advertisement to travellers that this was where to head in order to cross the Severn in comfort in exchange for a few pennies.

CHALFORD

Recorded as Chalforde around the middle of the thirteenth century, this name is clearly from Old English *cealc-ford* and describing 'the chalk or limestone ford'.

Two names locally are derived from Old English. Abnash Farm refers to 'Abba's ash tree' and Bussage speaks of this being 'Bisa's ridge of land'. However Rack Hill comes from Middle English *rakke*, referring to a tenter frame which allows fabric to be dried after being treated, the fabric stretched across the frame and clipped in place would have been a common site in England for centuries.

CHARFIELD

Domesday tells us this was Cirvelde in 1086, a name which comes from Old English *ceart-feld* and describing 'the open land by a curved or winding road'.

CHARINGWORTH

With a record of Chevringavrde in Domesday, this is 'the enclosure of the family or followers of Ceafor' and features a Saxon personal name followed by the Old English *inga-worth*.

CHARLTON ABBOTS

A common basic name derived from *ceorl-tun* speaks of 'the farmstead of the freemen or peasants' is given a distinctive second element from its later possession by Winchcomb Abbey. The place is recorded as Cerletone in 1086 and Charleton Abbatis in 1535.

Local names from the Old English tongue include: Belas Knap from *bel-cnaepp* and describing 'the beacon hill'; Cotehay or 'the cottage enclosure'; Goldwell Farm is from *golde-wella* is 'the stream or spring where marigolds grow'; and Cold Kitchen points to 'the exposed kitchen garden', which does seem an unusual choice of location for such a place.

CHARLTON KINGS

As with the previous name this is 'the farmstead of the freemen or peasants', here the distinction shows it was an ancient demesne of the Crown. The place is listed as Cherletone in 1160 and Kynges Cherleton in 1245.

Ashley Manor was built at the 'ash tree clearing'; Timbercombe was 'the valley where timber was obtained'; and The Hearne speaks of 'the angle or corner', a plot of land in the angle where two lanes converge. Battledown has nothing to do with any conflict but is a corruption of Baedela's farmstead'; Cudnall began life as 'Cuda's hill'; what was 'Hraefn's gap' is today Ravensgate Hill; and Jenning's Grove was the home of Thomas Gennine in 1589.

While the Duke of York is a popular pub name, it is very difficult to tell which specific holder of the title is being honoured. It is always bestowed upon the second son of the reigning monarch upon the occasion of his marriage. While many pubs of this name show a scene representing the children's nursery rhyme the *Grand Old Duke of York*, it should be noted that this rhyme refers to Frederick Augustus, son of George III and commander of the British Army in Flanders at the end of the eighteenth century. Whilst this Duke of York may well have been 'grand' he was certainly not old for he was only 31 at the time, he commanded over 30,000 men and, while he certainly marched them, there are no hills around Flanders whatsoever!

The Ryeworth Inn takes the name of the Ryeworth Road which, in turn, is a place name speaking of 'the enclosure where rye grows'; Mary Fellow Inn appears to refer to the parish church of St Mary's and the Glenfall Fellowship; while the Clock Tower is another pub with a religious connection.

CHEDWORTH

This Saxon place name is recorded as Ceddanwyrde in 862 and Cedeorde in 1086, 'the enclosure of a man called Cedda' features the Old English element *worth*.

Locally we find several place names of note. Huntage takes its name from 'Hodde's or Hudde's ash tree'. Postcombe is derived from Old English *pusa-cumb* and describes 'the bag-shaped valley', that is having a natural exit only at one end. Boys Grove has nothing to do with children but recalls the family of de Boys who were here in 1327. Chestells gound takes its name from *ceastel* meaning 'the heap of stones'. Pinkwell comes from *pinca-wella* or 'the spring or stream frequented by finches' and is one of

two places name which are derived from the local birdlife. At first glance there is no obvious connection between Chatterpie Grove and 'magpies', however the black and white member of the crow family is referred to by this dialect term and a fair description of its recognisable call.

The local here is the Hare & Hounds, a name reminiscent of the traditional country pursuit of hare coursing. Banned in the UK since 2005, in effect the hare was rarely caught by the dogs, the purpose being to test the ability of the dogs to pursue and turn the native lagomorph. While most images show the dogs as greyhounds, lurchers and beagles were also used — indeed any dog which has well developed eyesight, for the hare was sought by sight and not by smell.

CHELT (RIVER)

A tributary joining the Rivern Severn at Deerhurst, which was long held to be a river named by back-formation from the town of Cheltenham. While each will doubtless have influenced the other, the two names developed quite independently from the same source. The river name is also seen in history named the Alr and also Aqua de Incham, quite different from the modern name. However this is not unexpected for most rivers would have had more than one name in earlier times. People did not travel extensively as we do today, while the name given to a river would have described it at one particular point — it may have been fast flowing, near ash or oak trees, deep or dark, liable to flood — all are common elements in the origins of river names but cannot apply to every part of a river. Indeed it is only when cartographers produced definitive maps that the river names applied to its entire length; furthermore it would have been purely by chance that any one particular name was recorded.

The alternative names for the Chelt come from places along its course. Both Alre and Incham are former field names and were eventually replaced by the river name which again refers to the '(river of) the slope called Celte'.

CHELTENHAM

With records of Celtanhome in 803 and Chinteneham in 1086, this is probably 'the enclosure by a hill slope called Celte'. However it is possible the first element may be the Saxon personal name Celta. However it is not a reference to the River Chelt, which is discussed above.

Local names taken from known tenants include Fiddler's Green, worked by William Fidler, Monkscroft, the place of work of Richard Munke, Hesters Way is a corruption of the name of William Herte, and Bayshill was named after Matilda Bayse. All these individuals were here during the reign of Henry VI, 1422-61.

Street names of Cheltenham include Merestones Road, referring to the 'boundary stones' of the old boundary with Leckhampton; Montpellier Street was the site of Montpelier Spa in 1830; and The Strand takes the name of 'the bank' of the River Chelt.

Minor names of note are Alstone or 'Aelf's farmstead'; Arle which is the '(place at) the alder tree'; Bayshill appears to a personal name such as 'Bevis or Beevis hill'; Benhall Farm comes from 'Beonna's nook of land'; Pilgrove Bridge tells us it was near 'the grove

C

where shafts for building were obtained'; and the local fauna were seen in the name of Harthurstfield Farm which gets its name from the 'hill wood frequented by harts'.

Pitville is named after Joseph Pitt MP, who was instrumental in developing the area near the spa. Sandford is where the road to Bath crossed the River Chelt at 'the sandy ford'. Brookbank Cottage was associated with the family of John or William Brookebank in 1571. Cambray takes the name of former resident Elizabeth Cambray, whose family and there name comes from Cambrai in France and who was here in 1561. What is now Tanners Lane was home to the family of Samuel Tanner in 1801. The unusual name of Gallipot Farm refers to a tiny earthenware jar which was used by an apothecary and was probably used here as a nickname for same.

Streets here include the themes so popular in the twentieth century, the Commonwealth, Welsh counties, butterflies, hills, shrubs, prime ministers, varieties of apple, south England counties, English poets, birds of prey, winners of the Cheltenham Gold Cup and the Lake District being some of the more easily recognised.

Baynham Way is named after paving commissioner Baynham Jones, who died in 1858 aged 85. Beale Road remembers Dorothea Beale (1858-1906), the first principal of Cheltenham Ladies' College. De Ferriers Walk was named after a man who served in public life for over 50 years, including two terms as mayor, the man with the impressive name of Baron Charles Conrad Adolphus du Bois de Ferrieres (1823-1908). Dowty Road remembers Sir George Dowty, founder of the Dowty aero-engineering group. Grimwade Close after Harry Charles Grimwade, who served as councillor during the first half of the twentieth century.

Hicks Beach Road after William Hicks Beach JP, made a freeman of the town in 1922. Lipson Road remembers Daniel Lipson, former mayor and member of parliament and another freeman of Cheltenham. Another former mayor of the twentieth century, also made a freeman of the town, was Charles Margrett CBE JP, who gave his name to Margrett Road. Monson Avenue remembers eighteenth-century property developer the Hon Miss Katherine Monson. Poole Way is named after former councillor Les Poole.

Cheltenham's long association with horseracing has produced several pub names reflecting this. The National Hunt refers to the sport, while Dawn Run and Golden Miller were famous champions, and Irish Oak and Lansdowne Bar refer to other names associated with the sport. Brewing is a popular theme, for obvious reasons, leading to the Jolly Brewmaster and the Hogshead, which is a large sized barrel. Families and places associated with the town gave names to the Exmouth Arms, Somerset Arms, Suffolk Arms, Bath Tavern, Craven Arms, Hewlett Arms, Russell Arms and Prince of Wales.

The Moon Under Water offers a different slant on the popular image of the moon, showing the reflection of Earth's natural satellite in the water. The names of the Brown Jug and the Cat and the Fiddle may be associated with the nursery rhymes, but the origins are probably only that they represent easily recognised images. The Beehive Inn is named such for the insect is synonymous with hard work, the staff here will do their utmost to make customers welcome.

The Frog & Fiddle is a created pub name, which has the added advantage of alliteration, the advertising man's dream. The Restoration Inn is an alternative to the usual royalist name of Royal Oak, this referring to the restoration of the monarchy and Charles II. Five Alls is a name from the seventeenth century and created to show the inn was available to everyone, the sign showing five individuals from the King, who rules for all; the Parson, who prays for all; the Lawyer, who pleads for all; the Soldier, who

fights for all; and the Labourer, who works for all. However the most imaginative name must surely go to one with a religious origin, to which has been added a promise of a fun evening in the name of The Pulpit (It's A Scream!).

CHERINGTON

Listed as Ceritone in Domesday, it seems this is from *cirice-tun* and describes 'the settlement with the church'.

One field name is taken from the 'boundary road' and appearing on modern maps as Meerway.

CHIPPING CAMPDEN

Listed in Domesday as Campedene and in 1287 as Chepyng Campedene, this name is derived from the Old English *camp-denu* and meaning 'valley with enclosures', with the addition of ceping or 'market'.

Berrington Mill is named to describe 'the borough farmstead'; Broad Campden still tells us it was 'the wider valley with enclosures'; the Hoo marks the location of the 'spur of land'; Pye Mill comes from Middle English *peo* ('insect' or possibly the Middle

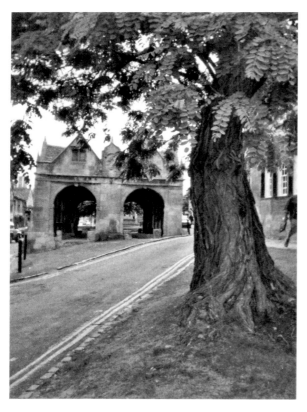

Chipping Camden Market Place

English byname *Pie*); and finally Wold's End is recorded as World's End in 1824 and thus not a reference to the hills or downs but a corruption of the name of World's End found on a map dated 1824 — a remoteness name, used ironically to describe the farthest corner of the parish.

Haysum's Close is named after George Haysum, who died in 1963 and who drove a Morris Commercial bus which serviced the town. A curious looking vehicle which has been said to resemble a delivery vehicle, a shooting brake, and even a hearse, depending upon the angle of the observer. It was nicknamed the Flying Greenhouse by visiting troops during the Second World War.

Three pubs of note here: the Red Lion Inn, the most common of all pub names and of heraldic origins, as is the case with the Bakers Arms which probably represents the former trade of the proprietor or landlord. The Churchill Arms refers to the family who are associated with Blenheim Palace and specifically to Captain Edward Spencer Churchill, the local squire who was the cousin of Sir Winston and who lived locally.

CHIPPING SODBURY

A name found in Domesday as Sopeberie and as Cheping Sobbyri in 1269, this name comes from Old English and refers to 'the fortified place of a man called Soppa', where the suffix is Saxon *burh*. The addition here, to distinguish it from Old Sodbury, is *ceping* meaning 'market'.

One of the most unusual street names is found here. Rouncival Street takes its name from an Early Modern English word *rouncevall* meaning 'a fat, boisterous, loose woman'. Unfortunately the woman is question was not named.

CHURCHAM

This place name refers to 'the church in the river meadow' from Old English *ciricehamm*. At the time of Domesday only the second element was present when recorded as simply Hamme, the earliest modern name appears in 1200 as Churchehamme.

Undoubtedly the name of Churcham has influenced the evolution of Saint Hill, although there is no religious connection to this minor place name. From Old English *senget* this name gives us an image of the place when it was first being settled, for the name tells us it was 'the place cleared by burning'.

CHURCHDOWN

Listed in Domesday as Circesdune in 1086, this name comes from two elements in Celtic *crug* and Old English *dun*, two words with identical meanings and giving a definition of 'hill, hill'. This simply means the Saxon settlers knew the name of the hill but failed to understand its meaning.

Two names which are linked are 'the pear farmstead' or Parton and Pirton which is distinctly different as 'the pear orchard farmstead'. Brickhampton Farm started life as 'Brihthelm's farmstead', while Drews Court reminds us of the Drews family who were here around the fifteenth century.

CHURN (RIVER)

A Celtic river name of uncertain meaning which is identical to that seen in Cirencester. A tributary of the Thames it is recorded as Innon Cyrnea in 800, andlang Cyrne in 999, and Churne in 1540.

CINDERFORD

Recorded in 1258 as Sinderford, this comes from Old English *sinder-ford* and describes the 'ford built up with cinders or slag' which came from local iron smelting.

Local pubs include the Royal Foresters Hotel, a reminder of royal hunting pastimes; the Forge Hammer Inn is an alternative to the usual reference to the village blacksmith, long associated with the pub and with horse travel, as indeed is the name of the Nags Head; the White Horse Inn is a widespread heraldic image, adopted by the kings of Wessex among many others, and are the White Hart Inn and the Red Hart Inn; Mount Pleasant takes the name already applied to this locality, and for obvious reasons, as does the Upper Bilson Inn; the New Inn is always a more recently opened establishment; the Rising Sun is a welcoming message to prospective customers; and the Malt Shovel Inn allowed landlords to show a simple and easily recognisable symbol of brewing.

CIRENCESTER

Listed as Korinion in 150, Cireceaster in 900, and Cirecestre in 1086, this comes from the 'Roman camp or town called Corinion' and features the Old English suffix *ceaster* following a form of a Celtic name of uncertain origin and meaning.

Locally we find some interesting names, including Black Jack Street which, while undoubtedly the name of an old inn, correctly refers to the drinking vessel. Not until Georgian times was there ever any glass in inns and alehouses, save for that which glazed the windows, ale was stored in wooden casks and served in a leather jug coated in tar to seal it, this jug known as a Black Jack.

Other street names recall the people of Cirencester: Sir Benjamin Bathurst bought the estate known as Cirencester Park in 1695, the family having lived there for the last three centuries, which leads to the naming of Bathurst Road. Countess Lilias Road is named after Countess Lilias (died 1943), wife of Seymour Henry, 7th Earl Bathurst who lived at the Cranhams.

Bowly Road is named after the Bowlys, a prominent local family of Quakers. Brooke Road and Vyners Close recall Sir Charles Vyner Brooke, Rajah of Sarawak who has close associations with the town. Colonel Thomas Chester-Master, the nineteenth-century owner of the former Abbey Estate, was the inspiration for Chester Street. Cripps Road is named after the Cripps family, of which the nineteenth-century MP Joseph Cripps is the best known.

Dugdale Road took the name of Major James Gordon Dugdale of Abbey House, who commanded the Local Defence Volunteers (later known as the Home Guard) during the Second World War. Elliott Road is named after Jack Elliott, Engineer and Surveyor to Cirencester Urban District Council from 1944 to 1973. Wilkinson Road took the name of the Clerk and Chief Financial Office of Cirencester Urban District Council from 1927

to 1959, Mr J. H. Wilkinson OBE. Grantley Crescent remembers Lord Grantley, who owned Oakley Hall.

Walter Hammond, a former pupil at Cirencester Grammar School, who played cricket for Gloucestershire and England gave his name to Hammond Way. Lawrence Road is named after Charles Lawrence, brother of the famous surgeon Sir William Lawrence, who built the Querns, a large house which was to become the town's hospital in the early nineteenth century. Roberts Close occupies the site of the former home of Stratton Rise, abode of Colonel Roberts.

Religious figures who have given their name to streets include Elphick Road, after Rev Richard Elphick who was Rector of Stratton 1946-62. Six centuries earlier Ralph de Estcote was Abbot of Cirencester 1352-57 and he gave his name to Escote Road. Hakeburn Road takes the name of John Hakeborne, Abbot of St Mary's Abbey 1504-22. Hereward Road is named after William Hereward, Abbot of Cirencester 1334-52. Glebe Close took its name from Glebe Farm, a common name which always shows the land was once owned by the church. The Vaisey family resided at the Glebe for many years and gave their name to Vaisey Road.

Berkeley Road is named after Reginald Berkeley, a local builder who bought two of the fields around this area shortly after the First World War. Alexander Drive is after Henry Alexander, the engineer who founded the Corinium Iron Works in 1849 and who earned a reputation for his construction of agricultural machinery and steam engines. The fifteenth-century wool merchant Thomas Arnold gave his name to Arnolds Way; and Coxwell Street after the seventeenth-century wool merchant's family of the same name. Carpenters Lane is named after Charles Carpenter, a gardener during the 1860s who lived in a house here next to the Talbot Inn. Farrell Close is named after Farrell's Engineering and Cycle Shop. Martin Close was cut on the former site of Cole & Lewis, whose bacon-curing factory was last owned by Martin Lewis, grandson of the co-founder.

Blue Quarry Road is named after the nearby Kingshill Quarry, where the bluish stone known as Forest Marble is quarried. The Waterloo is not named after the famous battle, or even the railway station, but from the type of sedan chair which carried ladies from this place to their carriages, thus they avoided treading through the filth which covered Market Place and badly soiling their long and voluminous dresses.

Phoenix Way is named after the Phoenix Inn. Golden Farm Road takes the name of the Golden Farm Inn, a seventeenth-century establishment most likely named for the famous golden Cotswold Stone from which it was built. The last resident of Golden Farm was Brigadier-General Ewing Paterson, after whom Paterson Road is named.

Cecily Hill takes its name from the local chapel dedicated to St Cecilia; Coxwell Street remembers John Coxwell, who left 20 shillings (one pound) per year to the church funds for sermons; Dollar Street took its name from the hall which stood here and being 'the street of the hall where charity is doled out to the poor'; Dyer Street was where cloth dyers worked; Lewis Lane was home to Adam de Lewes, who held land from Margaret de Bohun in the fourteenth century.

Thomas Street was the site of the Hospital of St Thomas; Oakley Wood ironically took its name from the part where there were no trees, for it means 'the glade or clearing in the oak tree wood'.

Spital Gate is found in the northern wall of the town, taking its name from St John's Hospital; Stratton takes its name from the Ermine Street between Cirencester and Gloucester and comes from Old English *straet-tun* or 'the farmstead on the Roman road'; Cranhams is a fairly common minor place name which, as here, invariably refers

to 'the river meadow frequented by herons or cranes'; while Grismond's Tower is at a location named as Grosmunt in 1540, a name meaning 'the great hill'.

Gumstool Bank takes its name from Middle English *gum-stoole* and refering to the place of the 'cucking stool' — a device used as a form of punishment, primarily for the crime of common scold (a woman who was constantly arguing with her neighbours), although it was also utilised for sexual offences such as prostitution, or having an illegitimate child. Clearly these were crimes which involved women. This should not be confused with a ducking stool, for there was a major difference between these ostensibly identical pieces of equipment. The ducking stool, as its name suggests, was used to dip the person on the stool into the water and the individual may well be in very real danger of drowning or dying from the shock of being plunged into freezing cold water. The cucking stool was more for humiliation, for the person would be raised on high and displayed to what was sure to be a reasonable crowd.

Formerly known as New Street, Querns Lane leads to The Querns, an area of the town which comes from Old English *crundel* meaning 'quarry'. However this is not the quarry which we would envisage today, for this is the area where a Roman amphitheatre, a Roman cemetery, tumuli, heaps of stones, old pits, an earthworks have provided untold hours of delight for archaeologists and historians.

Bingham House was built as the public library and later housed the town council chambers. It was built by Daniel Bingham, who was born in Black Jack Street in 1830, and who worked for the Great Western Railway at both Cirencester and Paddington Stations. He was sent to Utrecht in the Netherlands to help organise the local railway system, as indeed were many British railway engineers who travelled the world. Returning to his hometown the now wealthy Bingham was a major benefactor for Cirencester and died here in 1916.

Pubs here include the Twelve Bells Inn, a name which refers to the nearby church and to the number of bells in the peal. Waggon and Horses is a name which reminds us that, prior to the railways, pubs were the major stops as goods were transported overland. Indeed the landlords made their premises available to act as warehouses and took on the role of agent. Although the modern spelling is normally seen as wagon, the preferred spelling is waggon even if this is normally only seen in pub names. The Marlborough Arms remembers the Churchill family, Dukes of Marlborough.

CLAPTON

Listed as Clopton from 1171, this name is derived from Old English *cloppa-tun* and means 'the farmstead near the hill'.

Three local names worthy of attention are The Swilley, a field which is found alongside the stream with 'a whirlpool'; Gomm's Hole which takes the name of former residents, the Gomme family; and Jarrett's Brow, which is recorded as Jarrets Leys in 1756, is named from the surname Jarrett and refers to the 'brow of the ridge'.

CLEARWELL

From Old English *clafre-wella* this place, recorded as Clouerwalle around 1282, is named from the spring or stream where clover grows'.

The Wyndham Arms takes the name of the family who had Clearwell Castle built around 1727, the Butchers Arms depicts the coat of arms granted to them in 1540, although the Lamb Inn is not related to the meat trade but is a message showing allegiance to the Church of England.

CLIFFORD CHAMBERS

Found in 922 as Clifforda and as Clifforde Chaumberes in 1388, this name means 'the cliff by the steep bank' with the manor being given to St Peter's of Gloucester in 1099 for the use of the chamberlain.

Willicote House takes its name from Old English *wilig-cot* or 'the cottages by the willow trees'; and that of Wincot is an abbreviation of 'Winna's cottages'.

CLIFTON

A common name which we would normally expect to find with a second, defining element and always meaning 'the farmstead by the cliff or steep bank'. St Vincent's Rocks were named as they were virtually in the shadow of the chapel dedicated to the saint.

COALEY

Domesday shows this record as Couelege in 1086, the name coming from Old English *cofa-leah* and describing 'the woodland clearing with a hut or shelter'.

Local names include Betworthy Farm, which comes from 'Bett's enclosure'; Coaley Peak marks the place of 'the pointed hill'; Elmcote was home to 'the hill men's cottages'; Lapley Farm was once a separate settlement known as 'Lappa's woodland clearing'; Manley Farm was 'the community or common woodland clearing'; Trenley House comes from an earlier place name of Old English *trendel-leah* or 'the circular woodland clearing'; Blind Lane began life as a 'cul de sac'; Boseley Close is from *bors-leah* or 'the woodland clearing of spiky plants'; the Freeze is a corruption of Old English *fyrhthe* or 'woodland'; Smarrow Hill is from *smeoru-hyll*, literally 'fat hill'; and the Isles of Scilly are here too, although only as a remoteness name, a jocular reference to the most distant corner of the parish.

The Fox and Hounds is a common pub name, often thought to be associated with the hunt it was as common in country where hunting did not take place and is thus probably popular for its imagery.

COATES

Listed as Cota in 1173, this comes from the Old English *cot* and tells us of the 'cottages or huts'.

Locally we find Tewsbury House, from *trus-burh* and meaning 'the fortification overgrown with brushwood'; Dockem House, from *docce-hamm* and 'the meadow

overgrown with docks'; Perrymore from *pirige-mor* of 'the pear tree moor'; and the Sleight, an Old English term *slaeget* and meaning 'the sheep pasture'.

Here can be seen the remnants of the canal linking the Thames with the Severn, a shortcut between England's two most important cities and ports London and Bristol. There are currently plans to renovate this stretch of canal for leisure purposes and one of the places to benefit will be the Tunnel House Inn. Completed in 1783, the canal cut through the hill for 2 ½ miles emerging at Sapperton. When re-opened narrowboats will be able to run through the tunnel using motor power, when from the eighteenth century the horse-drawn boats faced a problem. Without a towpath the horse was unable to pull the barge and was led over the hill by hand. Meanwhile the boat was 'legged' through the tunnel by two men lying on the roof of the vessel and walking sideways along the arch of the walls/ceiling. Having attempted this, the author can reveal this would not have been an easy task for a few yards — while the prospect of 2 ½ miles is positively terrifying.

COBERLEY

From the Old English *leah* with a Saxon personal name, here is 'Cuthbeorht's woodland clearing' which is listed as Culberlege in 1086.

Within this area we find Hartley Farm, from Old English *heorot-leah* 'the woodland clearing of the harts or stags'; Wistley Hill takes its name from 'the clearing near a swampy meadow'; Salterley Grange tells us this 'woodland clearing of the salt dealer'; Ullenwood which is not a personal name but tells of the 'owl's wood'; Fatting Close was where animals were fattened; and Seven Springs, often cited as the source of the Thames, is actually that of the River Churn.

CODRINGTON

Meaning 'the farmstead associated with a man called Cuthhere', this is recorded as Cuderintuna in the twelfth century.

COLD ASHTON

Here is a name which offers no surprises, for indeed it does refer to 'the exposed farmstead by the ash tree'. Locally we find Hamswell or 'the spring near a homestead', while Tog Hill comes from the '(place at) Togga's hill'.

COLEFORD

Found as Coleforde in 1282, the Old English *col-ford* combination speaks of 'the ford across which coal is carried'. Note this is charcoal used as fuel and not the fossil fuel so controversially burned today. The minor name of Scowles is a word meaning 'rubbish, debris' and used to refer to where coal and ore pits in the Forest of Dean have collapsed.

Pubs at Coleford include the Dog and Muffler, a name which likely began as simply the Dog (an easily recognisable image) and which took the addition to differentiate from the many others and indeed is almost certainly unique. The Gamekeeper Inn is as commonly used as a tongue-in-cheek reference to a poacher as it is to a gamekeeper, inspiration coming from the adage 'poachers make the best gamekeepers'. Globe Inn is a simple image to reproduce while also suggesting a welcome to all, and the Hope Pole Inn is a reference to the hops used in brewing which were once trained along poles but today use a framework of wires.

COLESBOURNE

A Saxon personal name with the Old English *burna* gives the place name 'the stream of a man called Col or Coll', and is listed as Collesburnan in the nineteenth century and as Colesborne in Domesday.

Minor names found here include Colesbourne Bottom, a name which has three equally plausible origins: 'the valley where cheese is produced' makes for a nicer image than 'the valley of the heap' but is less intriguing than 'the valley of the dispute or strife'. Pinswell comes from *pynd-wella* 'the pond spring'; Balburrow Wood takes its name from 'the grove of tree trunks'; while Rapsgate is derived from Old English literally describing the '*geat* of blame' and understood to be a place where punishment was meted out.

COLN (RIVER)

A tributary which joins the Thames near Bibury, it is recorded as Flavium Cunuglae in 721, bi Cunelgan in 855, and be Culne in 1320. This name has never been explained, however the upper course of this river is known as the Tilnoth, which is discussed under its own listing.

COLN ROGERS

The basic name here comes from the River Coln, a Celtic river name discussed above. The addition, for distinction from the following names, is first seen in the thirteenth century as Culna Rogeri and refers to possession by Roger de Gloucester who is known to have died in 1106 and therefore the name was in use for many years before this first known record.

One interesting name is that of Pindrup Farm, which features the Old English element *pinn* meaning 'peg' and referring to a particular 'building or structure held together by pegs'.

COLN ST ALDWYNS

Again from the River Coln, a Celtic river name which has defied all attempts to understand it, which has the addition of the dedication of the church to St Athelwine and is first recorded as Culna Sancti Aylwini in the twelfth century.

Minor names here include Cockrup Farm, a name which comes from a combination of Old English *cocc* and Middle English *throp* and referring to 'the outlying farm where cocks are bred', although it may be this first element is a personal name, maybe a nickname, *Cocca*. Swyre Farm comes from Old English *sweora* or '(place at) the neck of land'. Williamstrip Park has three elements, each from a different era of British history: Middle English gave us Park, a managed landscape; at the time of the Norman Conquest it was held by Willelm from Roger de Laci; while the middle segment is the original name of the place, from Old English *throp* and referring to the 'outlying farmstead' the name of Hetrop seems to have been influenced by neighbouring Hatherop.

COLN ST DENNIS

A third name from the unknown Celtic river name of Coln, here the dedication of the church to St Denis of Paris makes it distinctive, a name first seen in 1287 as Colne Seint Denys.

Local names of note are Calcot, 'the cold cottage'; Bratch Copse, 'the land newly broken up for cultivation'; and Leighteron Barn from Old English *laehtric-tun* and constructed where there was 'the farmstead where lettuce is grown'.

COMPTON ABDALE

Listings of Contone in 1086 and Apdale Compton in 1504, the common-place name is derived from Old English *cumb-tun* 'the farmstead in the valley', with the addition referring to possession by the Apdale family by the sixteenth century.

The Puesdown Inn, an old coaching inn with at least one resident ghost, takes the name of the ridge along which the modern A40 runs. The name is most likely a corruption of 'Pugh's down or hill slope'.

CONDICOTE

Recorded as Cundicotan and Condicote in the eleventh century, this is a Saxon personal name with Old English *ing-cot* and tells of 'the cottage associated with a man called Cunda'. The village gave its name to Condicote Lane which connects with Buckle Street in Saintbury, through Condicote and meets the Fosse Way at Bourton on the Water.

The local name of Hinchwick is derived from the Old English telling us it was 'Hynci's dairy farm'.

CONE BROOK

A small tributary which meets the Severn in Aylburton is recorded as Cone in 1270 and in the modern form for the first time in 1830. It seems this must be related to an Early Modern English word *coane*, now virtually obsolete but meaning 'gap, fissure, cleft'.

CORSE

An unusual name for it has retained the Celtic name for a village, when normally these are reserved for topographical features such as rivers and streams. This is recorded as Cors in 1165 and is from Celtic *cors* and refers to 'the bog or fen'.

COTSWOLDS

A regional name which must have started as a localised area and eventually been adopted by the entire range of hills. It is first seen as Codesuualt in the twelfth century, and comes from 'the high forest of a man called Cod'.

The Cotswold Way runs from Chipping Campden to Bath and takes its name from the region. As the name suggests it follows the line of a ridge of chalk for 105 miles, yet is just a small portion of the prehistoric track which ran from the Humber to the Bristol Channel.

COWLEY

A fairly commonplace name derived from Old English *cu-ley* and meaning 'the woodland clearing where cows are pastured'. It is recorded as Kulege in Domesday.

Locally we find Birdlip, a name from Old English *bridd-hliep* and referring to 'a steep place' and, somewhat overly dramatically, literally describes it as where the only way to leap from this place was by flying. Stockwell takes its name from the 'spring by a tree stump', with 'the dove enclosure' now known as Culerhay.

The Green Dragon, while invariably shown as being related to the story of England's patron St George is undoubtedly a reference to the Earls of Pembroke who feature same in their coat of arms.

CRANHAM

The earliest record from the twelfth century is identical to the modern form. This is from the Old English *cran-hamm* and telling of 'the river meadow frequented by cranes or herons'.

Here is Brotheridge, a name describing 'the broad ridge'; Ladlecombe which can still be seen to describe 'the spoon-shaped hollow'; Batch Farm takes its name from *bece*, 'stream'; the Hacket was 'the cleared region'; while Climperwell, a name literally meaning 'a lump of metal' is the source of the River Frome — clearly the waters or the stream were associated either with the search for metals or with the production or smelting of metals.

CROMHALL

The Domesday record shows Cromhal, from Old English *crumbe-halh* and meaning 'the nook of land in a river bend'.

The name of Ashworthy Farm comes from Aescela's enclosure'; Hawley's Lane runs to or past 'the woodland clearing where haws grow'; and Hammerley Down tells us of 'the hammer sedge clearing on a slope'.

CULKERTON

Domesday's Cvlcortone points to the Old English *culcor-tun* and means 'the farmstead with a watering hole'. However it is also possible the first element is a personal name, thus we should also offer 'Culcere's farmstead'.

CUTSDEAN

Recorded as Codestune from the tenth century and Cottesdena by the twelfth century, this is either Old English *tun* or *denu* and giving 'Cod's farmstead' or 'Cod's valley' respectively.

The name of Kitehill from *cyta-hyll* or 'the hill frequented by kites'; and Dirty Bridge comes from Old English *brec* and speaks of 'the muddy land broken up for cultivation'.

Chapter Four

D

DAGLINGWORTH

A name recorded around 1150 as Dalingworth has two possible origins. Either this is Old English for 'the enclosure of the family or followers of Daeggel or Daeccel', or 'Daeggel or Daeccel's enclosure'.

Field names here tell something of the history and early layout of the area. For example, Twitching Hill comes from Old English *twicerne* or 'the short steep bend in a road'; Bile Shore comes from *bi-wall* or the '(place) by the wall'; and Smoke acre, which originally referring to land held by the payment of a money tax, known as smoke penny, or smoke silver, and a tax put in place of tithewood.

DAYLESFORD

Recorded as Daeglesford in 718 and Eilesford in 1086, this name refers to the '(place at) the ford of a man called Daegel'.

DEERHURST

Records of Deorhyrst and Derherste from 804 and 1086 respectively, show this to be from the Old English *deor-hyrst*. This place name speaks of the '(place at) the wooded hill frequented by deer'.

The name of Cobney Meadow has changed little since it began as 'Cobba's water meadow'; Notcliffe House tells us of 'Hnotta's cliff'; and Wightfield Manor comes from Old English *wiht-feld* 'the open land with or at a bend'. Naight Brook is a secondary man-made drainage channel here running to the Severn, between the two is an island referred to in Middle English as *atten-ait* or 'at the small island'.

DIDBROOK

Recorded in 1248 as Duddebrok, here a Saxon personal name precedes Old English *broc* to give 'the brook of a man called Dydda'.

Bittam Piece is a corruption of 'the bottom piece of land'; Dances Hay began life as 'the enclosure of a family called Dance'; and Throughter Piece features the dialect term *throuter* which refers to 'a ridge of land running through a common field'.

DIDMARTON

The same personal name is seen in this name as was seen in Didbrook, although whether the brook gave its name to the place or vice versa is debatable. Recorded as Dydimeretune in 972 and Dedmertone in 1086, this is either the 'farmstead by Dydda's pool' from Old English *mere-tun*, or 'boundary farmstead of a man called Dydda' if the element is Old English *mere*.

DIKLER (RIVER)

A tributary of the Windrush which it meets at Bourton-on-the-Water. This name is of Old English or Saxon derivation from *thicce-laefer* meaning 'the stream with the dense reed bed' and recorded as Thickelewe in 1241 and the Dickler in 1779.

DIXTON

Early records of this name are found as Dricledone in 1086 and Diclisdon in 1169, which is probably from Old English *dic-hyll-dun* meaning 'the dikes or earthworks of the down of the hill'. However it is possible the first element is a personal name, in which case it would be something akin to *Dicel* or *Diccel*.

DODINGTON

Domesday's record of Dodintone is the only early form, however this is quite easy to see as 'the farmstead associated with a man called Dudda or Dodda' from the Old English *ing-tun*.

Buckets Hill recalls the Bucket family who were here in 1779.

DONNINGTON

The similarity with the previous name is also seen in the definition of 'the farmstead associated with a man called Dunn or Dunna'. Again the suffix is Old English *ing-tun* and it is listed as Doninton in a document dated around 1195.

This parish includes the names of Duncombe House, which takes its name from what was once 'Dunna's valley'; and Crawthorn Wood reminds us that 'the thorn bush frequented by crows' gave this region a name.

DORSINGTON

A name telling us it was 'the farmstead associated with a man called Deorsige', where the Saxon personal name is followed by Old English *ing-tun*. The name is recorded as Dorsitune in 1060 and as Dorston in 1525.

Local names include Braggington, a name referring to 'the farmstead associated with a man called Bragga'.

DOUGHTON

With the earliest listing of Ductune around 775, this is undoubtedly from the Old English *duce-tun* and speaking of 'the duck farmstead'.

DOVERTE BROOK

A tributary of Little Avon which it reaches at North Nibley is found recorded in AD 940 as dofer lan. This early record shows the name comes from either British *dubro-glano* 'the pure waters' or a combination of British *dubro* and Welsh *glan* giving 'the waters of the bank or shore'. Furthermore these forms show the modern name is a corruption which should have become the Doverle Brook and, as this clearly could not have happened through pronunciation, must have been a written error.

DOWDESWELL

During the eighth century this is recorded as Dogoeswellan, which by Domesday is found as Dodesuuelle. Here the personal name is found with Old English *wella* and gives 'the spring or stream of a man called Dogod'.

Plenty of minor place names of note here: Andoversford or 'Anna's ford'; Lineover Wood is derived from 'lime tree bank wood'; Pegglesworth was 'Peccel's enclosure'; Rossley Manor comes from *hrost-leah* or 'the woodland clearing where beans are obtained'; Camp refers to an ancient encampment east of Dowdeswell Court, while Castle Barn is a similar site to the south; and Cold Comfort is in an 'exposed position'.

Field names here include Bowsing Ground where there was a bowsen or 'cow shed'; Hunger Platt was the site of a 'small patch of poor land'; Four Days Math would have taken 'four days mowing'; and the name of St Paul's Epistle marks a mound where extracts from the Epistle of St Paul were read during the annual ceremony of beating the bounds — an exercise in blessing the parish boundaries in order to ensure a bountiful harvest.

DOWN AMPNEY

The basic name here is dervived from Old English for 'the stream associated with a man called Amma', today known as Ampney Brook. The addition comes from Old English *dune* meaning 'lower downstream' and named to differentiate from other Ampneys in the county, it is listed as Dunamenell in 1205.

One simple place name here is mentioned in *The Ecclesiastical History of the English People*, finished in 731 and written by the Venerable Bede it is the first work on the history of these islands and earned the author the title of 'Father of English History'. Fixed borders are rare, not even a mountain range, a major river, or even an expanse of ocean will prove more than a natural barrier, for as a border it exists only while those on either side allow it and thus it is difficult to show a border existed centuries later. Such is the case with the name of The Oak, a name which is mentioned by Bede as being on the border between the tribes of the Hwicce and the West Saxons. If this is so, it is also where St Augustine, the first Archbishop of Canterbury, arranged to meet met with representatives of the British pagan religions.

Other names her include The Breach, a field name from Old English *brec* and meaning simply this land was 'broken up' and cracked, making it difficult to plough when it dried out. Maps also record a Galley Leaze Copse, from Old English *glaga-laes* and referring to 'the gallows meadows'. Whilst the idea of a gallows being erected here cannot be ruled out, it is more likely the name has developed from either the idea of an 'overhanging' feature and anything from a branch to a whole wood, or maybe where there was talk of a single hanging or killing.

DOWEND

A comparatively recent name which is first found in 1573 as Downe ende. It means exactly as it seems, the 'end of the down'.

DOWN HATHERLEY

Recorded as Dunheytherleye in 1273, the basic name here comes from Old English *hagu-thorn-leah* and speaking of 'the hawthorn clearing'. There is less than a three miles between this and Up Hatherley, hence the addition, and referring to up and down stream and not elevation.

DOYNTON

Recorded as Didnintone in 1086, Domesday's record shows this to be 'the farmstead associated with a man called Dydda', where the Saxon personal name is followed by the Old English *ing-tun*.

Bowd Farm is the modern version of the earlier Boud Farm, this being the Middle English variation of the modern surname Boyd.

DRIFFIELD

A place name recorded as Drifelle in 1086 and as Driffeld in 1190. There are two potential Old English words for the first element, which is either *drit-feld* giving 'dirty or grubby open land' or *drif-feld* which would suggest 'stubbly open land'.

DRY BROOK

From Old English *dryge-broc* and recorded as Druybrok in 1282, this name refers to 'the seasonally dry brook'. This is a tributary of Cinderford Brook which in reaches at East Dean.

DUMBLETON

Recorded in 995 as Dumbeltun and in 1086 as Dubentune, this name comes from Old English *dumbel-tun* and meaning 'the farmstead near a shady glen or hollow'.

Cotton's Farm takes the name of Alice Cotton who was here in 1622 or of Mary Cotton in 1672, while Cullabine Farm was home to Mary Cullabine by 1765. It is unusual to find two names having three potential origins and all three are females.

DUNKIRK

A name which comes from Dunkerque in France, transferred here it speaks of 'the dunes of the church' where it fits the more famous French location perfectly.

DUNTISBOURNE (ABBOTS, LEER & ROUSE)

Recorded as Duntesburne, Dantesborne, Tantesborne, and Duntesborne in the eleventh century, this basic name comes from 'the stream of a man called Dunt' with the personal name suffixed by Old English *burna*. There is less than a mile between the three places, and some maps also show a fourth of Middle Duntisbourne with obvious meaning. The additions are first seen as Duntesbourn Abbatis in 1291, referring to the possession by the Abbot of St Peter's Abbey of Gloucester; Duntesbourn Lye in 1307, alluding to the Abbey of Lire in Normandy; and Duntesbourn Rus in 1287, marking possession by the le Rous family.

At Duntisbourne Abbots is the smaller region of Duntisbourne Leer, which in 1086 was a region held by the Abbey of Lire in Normandy and given by Roger de Laci. A region called the Creephole was not a eerie as it would seem, simply a 'hole or gap in a field through which sheep could creep'.

Duntisbourne Rose sees Pinbury Park or 'Penda's fortified place', although this is not the Mercian king but would be a pet form of a name such as Penhere or Pendraed. Francombe Wood is 'the valley of the Frome'; Sly's Wall Plant reminds us of former residents John Slye who was here in 1579 and Joanna Sly in 1706; Voxhills is a corrupted form of 'the hill of the foxes'; and Clapyalls a dialect clap-gate, describing the 'gate that shuts on two posts and allows people through but not animals'.

An eighteenth-century inn lies just five miles from Cirencester, hence the name of the Five Mile Inn.

DURSLEY

Domesday records the name as Dersilege, from the personal name with Old English *leah* and referring to 'the woodland clearing of a man called Deorsige'.

Woodmancote can still be seen as referring to 'the woodman's cottage or shed'; Caswell Farm was created around the 'watercress spring'; and Cooper's Wood reminds us that Richard Cooper was here in 1676. Two names which were clearly created are Knackery Wood and Money Mines, neither of which have readily identifiable meanings.

Pubs around Dursley include the Old Spot, the name of a famous racehorse owned by the Duke of Nottingham as well as the breed of pig; the Lammastide Inn was built on the field of that name, a place where the first wheat was harvested and ground to produce the first loaf of the new crop, Lammastide being around 1 August; the Yew Tree Inn takes the name of the most permanent nearby landmark; and the Pickwick Inn is named after Samuel Pickwick, the eponymous figure in *Pickwick Papers* and one of Charles Dickens' most popular characters.

Dursley signpost

D

DYMOCK

Recorded in Domesday as Dimoch, this name is derived from a British or Celtic word *din* meaning 'fort'. Clearly there is a second element here which, from experience, we know would be descriptive and in place of an adjective. However without a written British record the form we have is too late to tell what idea was being conveyed.

A former landholder or landlord gave his name to the Beauchamp Arms. Callow Farm sits on 'the bare hill'; Gamage Hall was home to William Gamage in the thirteenth century; Swords refers to the Sword family, here in 1840; and Vell Mill takes its name from Old English *vell* meaning 'hide, skin' and related to vellum, the parchment made from animal skin, and we can be fairly confident this is what was produced here.

DYRHAM

Recorded as Deorhomme in 950 and Dirham in 1086, this name comes from Old English *deor-homme* and meaning 'the enclosed valley frequented by deer'.

Hinton comes from 'the high farmstead', while Tolldown Inn was constructed on 'the hill where a toll was paid'.

Chapter Five

E

EAST DEAN

The basic name comes from Old English *denu* 'the valley' here being east of other places sharing the element Dean'.

Local names include Sneyd Wood, or 'the detached part of the estate'; Soud Ley, an unusually accurate evolution from the original *sud-leah* and meaning 'the southern woodland clearing'; the Delves is still to be seen as 'the quarries' as the verb 'delve' is still used to mean 'seek, search'; and the name of Vention is an abbreviation of 'invention' and refers to some new piece of equipment which was not really understood.

EASTINGTON

A name recorded in 1220 as Esteuneston and which is derived from a Saxon personal name with Old English *tun*, thus speaking of 'Eadstan's farmstead'.

While Norbury Camp is clearly the name of 'the northern encampment', the name of Cats Abbey Barn is a little more complicated. The name has often been said to be derived from a meaning of 'the place infested with cats', yet there is no logic in this statement. Cats are naturally independent, fiercely competitive, and where a place is 'infested' by cats (or indeed any predator) there must be an even greater infestation of prey, presumably rodents, and thus it would be named Mouse Abbey Barn. More likely this is a personal name.

While the name of Alkerton comes from 'Alhhere's farmstead'; other points refer to their association with the town — such as Nastend or 'the east end (of town)'; Nupend or 'the upper end (of town)'; and Oldbury was 'the old part (of town)'.

EASTLEACH MARTIN

A name found in historical documents as Lecche in 862, Lecce in 1086, and Estleche Sancti Martini in 1291. This is the 'eastern place on the River Leach', where the stream name is prefixed by Old English *east*. Furthermore we can understand the name of the river, which comes from Old English *lece* and referring to 'the stream through boggy land', which might seem obvious but not all streams run through marshland all year

round today and would not have done so a millennia or more ago. The addition here refers to the church dedication to St Martin.

Minor names around the parish have given names to modern features. Coate Farm undoubtedly came from Old English *cot* or 'cottages', while the places was recorded as Pryors Cotes in 1561 where the first element was the name of the (then) owner. From its beginnings in Old English *stan-ford-brycg* or 'the stone ford bridge', the name has evolved to become Stafford's Bridge. While Smeril Plant takes its name from Old English *smeoru-hyll* or 'the hill with butter-producing pasture', with the addition of a reduced form of 'plantation'.

Fyfield is a common minor place name, which is of Old English origin in *fif-hid* or 'five hides', a region of land roughly equivalent to 150 acres. Here the name has been adopted by the field name Fyfield Forty, something of a misnomer for there is no second numerical value here, this is from *ford-eg* and describing 'the island (or dry area) in marshland'.

Other field names seen in Eastleach Martin include Wherns Slow, a corruption of *cweorn* 'mill stone' and *sloh* 'mire' and somewhere old mill stones were dumped. The oddly named Pig-neights comes from *pigga-eged* or 'pig island', again a drier region in marshland where domesticated pigs were kept. There is also the field name guaranteed to pique the interest of many a schoolboy, although the actual meaning of Turdy-corner is a more general 'filthy'.

The Victoria Inn recalls the longest-serving monarch, Queen Victoria reigned from 1837-1901.

EASTLEACH TURVILLE

A second place name telling of 'the eastern place on the River Leach' literally 'the stream through boggy land'. Here the addition refers to the manorial holding by the de Turville family who were here in the thirteenth century as evidenced by the record of Estleche Roberti de Tureuill in 1221.

Field names here include Blunts Hay of 'Blount's enclosure'; Clatley Hull, from three Old English terms *clate-leah-hulu* and describing 'the shed in the woodland clearing where burdock grows'; and Ranging Plott, which is a more modern name for a large area and is perfectly described by a record of 1723 as 'a pasture for 600 sheep to range over'.

EBRINGTON

Here is 'Eadbeorht's farmstead', the personal name suffixed by Old English *tun* and recorded as Bristentune in 1086 and Brihttona in 1155.

Minor names of this parish include Battle Bridge, which is taken from Battledene Farm, itself nothing to do with a dispute but a corruption of Baedela's brook'. Charingworth comes from 'Ceafor's enclosure', the personal name here is a nickname meaning 'beetle'. Hoarston is on the country boundary and merits the name of *har-stan* or 'the boundary stone'. Hidcote Boyce takes the basic name from 'Hydeca's or Huda's cottage', with the addition referring to the tenancy of Ernulf de Bosco in 1200 or Earnald de Bosco in 1212. From the Latin *boscus* this is an Old French name meaning 'wood'.

EDGEWORTH

A name recorded as Egesworde in 1086 and as Eggewurthe in 1220, this name comes from a Saxon personal name and Old English *worth* and describing 'Ecgi's enclosure'.

Locally we find a fairly common name in England, when Hanging Hill has often produced a number of fanciful etymologies. However there is no gallows associated with this name, this refers to woodland on a steep hill and comes from Old English *hangra* literally 'hanging'.

ELBERTON

Domesday's Eldertone and Albricton from 1186 both point to an Old English origin of Aethelbeort's farmstead'.

The unusual name of Mumbley's Plat is a field which features the element *plat* or 'plot of land' which was associated with the Mumbly family in 1840.

ELKSTONE

Here the Saxon personal name is followed by Old English *stan*. This name speaks of the '(place at) the boundary stone of a man called Ealac', and is recorded as Elchestane in 1086.

Local names include Combe End, the 'place at the end of the valley'; and 'the ford where darnel or tares (a species of ryegrass) grows' which is now known as Cockleford.

Here the locals enjoy a glass of their favourite tipple at what was the Huntsman and Hounds in 1781, by 1856 it was the Masons Arms and, following extensive restoration in the 1960s, the Highwayman Inn.

ELL BROOK

This tributary of the River Leadon joins it at Upleadon. This river name is of Old English or Saxon origin from *elm-broc* and refers to 'the stream where elm trees grow'.

ELMORE

The earliest record of this name is as Elmour in 1176, which shows this to be from Old English *elm-ofer* and describing 'the ridge where the elm trees grow'.

Here we find Farleys End, a name telling us this was 'the woodland clearing overgrown with ferns'.

ELMSTONE HARDWICK

A name recorded as Almundestan in Domesday, when the name referred to 'the boundary stone of a man called Alhmund', with the personal name followed by Old English *stan*. Hardwick has been added much more recently, it being linked with neighbouring Hardwicke less than a mile away.

The name of Knightsbridge tells us it was once 'the bridge where youths congregated'; while Piff's Elm grew alongside the home of Richard and William Piffe who were here in 1765.

One of the most famous breeds of pig is the Gloucester Old Spot, once a very popular breed of pig which became less commonly found on farms in favour of more productive animals. However in recent years the old breeds are making a comeback for the flavour of their meat is increasingly sought after by consumers.

ENGLISH BICKNOR

Listed as Bicanofre in Domesday, the basic place name comes from Old English *bican-ofer* 'the ridge with a point'. By the middle of the thirteenth century this had become Englise Bykenore, which tells us it stands on the English side of the River Wye.

Undoubtedly one of the most breathtaking vistas anywhere in England, the view from Symonds Yat must have been just as inspirational when it was 'Sigmund's gap'.

ERMINE STREET

This is the road from Silchester to Gloucester and, while it is a Roman Road, is not the original name of the road. Sadly the original name is unknown, suggestions being speculative at best. The original Ermine Street ran from London to the Humber, did not come anywhere near Gloucestershire, nor was it even named during the Roman occupation. Indeed the original was named after a settlement in Cambridgeshire, today known as Arrington and recorded as Earninga straet in 955, this is 'the Roman road of the family of followers of a man called Earna'.

However it is true to say that, as Ermine Street, the name is synonymous with a Roman road, even if neither the name nor the era are particularly accurate.

EVENLODE

A name recorded as early as 779 as Eownilade, which we are certain refers to 'Eowla's ferry crossing'. While we have no further knowledge of the man, we do know he not only gave his name to the settlement, but also from the settlement the name of the River Evenlode, a tributary of the Thames, in a process known as back-formation.

Locally is the place known as Four Shire Stone which, in the year of 969, was the point where the counties of Gloucestershire, Oxfordshire, Warwickshire and Worcestershire met.

EWELME (RIVER)

A river name which is recorded as aewylme in 940 and Ewelme as early as 1453, which shows this comes from Old English *ae-welm* and meaning 'the spring, the source of the river'. This river feeds the Cam at Uley.

EWEN

Listed in 931 as Awilme, this name is derived from the Old English *aewelm* and telling us this was the '(place at) the source of the river'.

 With the Wildfowl Trust at Slimbridge under twenty miles away, the naming of the Wild Duck Inn reminds us of its founding in November 1946.

Chapter Six

F

FAIRFORD

A name which is recorded as Fagranforda in 862 and Fareforde in 1086, and which comes from the Old English *faeger-ford* describing 'the fair or clear ford'. It is only natural our mind goes to the quality of the water when we hear 'clear' and yet it is more likely to refer to the approaches being free from vegetation.

Locally we find Milton End, from Old English *middel-tun-ende* or 'the middle farmstead by the boundary', in this case the River Coln, and which gave a name to Milton Farm. Garsons is a field name describing 'the paddock farmstead' from Old English *gaers-tun*; Lot Meadow describes the shape, for holt is a Saxon term for a 'strip'; and Woe furlong comes from *woh* meaning 'crooked'. The Saxon furlong was not the imperial measurement of 220 yards, still used in horseracing, but from *furh* 'furrow' and *lang* 'long' and the distance one could expect to plough before the plough team required a rest. It was a difficult task to turn the cumbersome plough and oxen of yesteryear, thus it made sense to plough long straight furrows without stopping. Clearly the distance travelled depended upon the soil, sticky mud or stony ground would be much harder to plough than a light loam which had been turned over a number of years. That a furlong was given as 220 yards is solely because it equates to one-eighth of a mile. A region one furlong in length and a width of one-tenth of a furlong, known as a chain and the length of a cricket pitch, gives an area of 4,840 square yards — the definition of an acre.

FALFIELD

From the Old English *fealu-feld* this is 'the fallow open land', referring to the colour rather than crop rotation. The name is first seen in 1227 as Falefield.

Local names are derived from the families who have lived here through the ages. However while it is easy to see family names in Jones's Wood and Skeay's Grove, this is less true with Swifts Wood and is unlikely to be recognised in the name of Sundayshill.

FARMCOTE

Found in Domesday as Fernecote, this name is derived from Old English *fearn-cote* and tells us this was 'the cottages among the ferns'.

FARMINGTON

It may come as a surprise to find all the early forms of this name suggest it should have evolved as Tarmington. From 1086 and 1182 respectively we find Tormentone and Tormerton, which is derived from Old English *thorn-mere-tun* and describes 'the thorn trees by the pool of the farmstead'. The change is either due to local pronunciation, or the misunderstanding of the origin of the name as the language evolved to Middle English and then to the language we speak today.

The field names of Smear Hill is taken from *smeone-hyll*, literally 'fat hill' and referring to where livestock were fattened up; and the Force Way which stands alongside the Fosse Way and is clearly a corruption of this name.

FIDDINGTON

In 1004 this is Fittingtun and in Domesday Fitentone, each show this to be from Old English and is 'the farmstead associated with a man called Fita', where the personal name is followed by *ing-tun*.

FILTON

The earliest record is from 1187 and is identical to that seen on modern road signs. This comes from Old English *filethe-tun* and describes 'the farmstead where hay is made'. Clearly the hay was not just for personal use, but cut and supplied to neighbouring settlements as fodder for their livestock.

Locally is Vellet Meed, from Old English *fellet* this is 'cleared of felled trees'.

FLAXLEY

Recorded as Flaxlea in 1163, this comes from the Old English *fleax-leah* and describes 'the woodland clearing where flax is grown'. Flax, a versatile plant grown for its fibres in Saxons times and used to make linen. Not only is it still known exactly as it was in Saxon times, albeit the spelling has altered a little, it is still processed in much the same way.

Harvested, soaked and beaten, it can be pulled apart into a mass of stringy fibres. A tool called a heckle, basically iron spikes in a wooden block, is used virtually as a comb to remove and remaining bark and bits of woody stem. After dressing the flaxen fibres are ready to be spun into the finished yarn. Flax produces a softer cloth than wool and, as a coarser much heavier yarn, was used to sew shoes, in the making of sails, and when working leathers.

FORTHAMPTON

Domesday shows this as Forhelmentone, with a Saxon personal name followed by Old English *ing-tun* and speaking of 'the farmstead associated with a man called Forthhelm'.

Locally we find Hooze Farm, a corruption of Old English *hoh* and referring to 'the hill farm'; and Swinley Green which tells us of 'the woodland clearing where swine are seen'.

FOREST OF DEAN

An ancient region which is not listed as such until the twelfth century as foresta de Dene, although it is quite possible there were many earlier records but these have been lost. The name comes from the Old English *denu* and speaks of the '(place in) the valley'.

FOSSE WAY

A road running from Bath to Moreton-in-Marsh, it is recorded as Foss in 779, Fose in 1221, and Fossway in 1457. This is undoubtedly from Old English *foss* and means 'ditch', a reference to the drainage ditch running alongside the road and something which was a Roman innovation.

FRAMILODE

This name is found in Domesday as Framilade, a name which refers to 'the crossing over the River Frome'. This is a Celtic river name meaning 'fair or fine'.

Standing almost on the banks of the River Severn at one of its widest points, it comes as no surprise that the local pub is the Ship Inn.

FRAMPTON COTTERELL

Found as Frantone in 1086 and Frampton Cotell in 1257, the basic name here is from 'the *tun* or farmstead on the River Frome'. The river name is thought to be 'fair or fine', while the addition speaks of the Cotel family, lords of this manor from the twelfth century.

Beesmoor describes 'the marshy moor'; Matford Bridge was 'the ford used at mowing time'; and Adam's Lane was home to Adam Cotell in 1167.

FRAMPTON MANSELL

Again this 'the farmstead on the River Frome, the fair or fine one', with the addition referring to the Maunsel family who were lords of this manor from the thirteenth century. The name is recorded as Frantone in 1086 and Frompton Maunsel in 1368.

The White Horse Inn is taken from the heraldic arms of one of several sources, most likely one associated with inns and horses such as coachmen, farriers, saddlers, wheelwrights and even innkeepers.

FRAMPTON ON SEVERN

And yet a third 'farmstead on the fair or fine one', and referring to the River Frome. Here the nearby River Severn provides the distinctive addition, a name of ancient beginnings discussed under its own entry.

There is a minor name here which is the fourth Frampton, that of Frampton Pill with the addition from Old English *pyll* referring to the 'tidal creek'. Wickster's Bridge takes its name from Old English *wic-stow* or 'the outlying dairy farm'.

A name such as the Bell Inn always shows a connection to the parish church, while the Three Horseshoes is actually a question asked when the answer was found alongside in the form of the village blacksmith.

FRETHERNE

Listings of Fridorne in 1086 and as Frethorne in 1236, defining this name reveals it was 'the thorn tree where sanctuary could be had'. However it does not tell us why sanctuary would have been sought, and from whom.

Minor names include Framilode, telling us of 'the crossing of the River Frome'; Saul comes from Old English *salh-leah* or 'the clearing of or by the willow trees'; Saul Worth is taken from the previous name and refers to 'reclaimed marshalnds along the River Severn'; Binhall speaks of 'the corner of land where beans are grown'; and Hock Crib is a reference to the natural stone breakwater in the River Severn.

FROCESTER

Listed as Frowcestre in 1086, this name comes from 'the Roman town on the River Frome'. As noted above this Celtic river name refers to 'the fair or fine one'.

Buckholt Wood takes its name from the '(place at) the beech wood'; Dowton is predictably 'the lower place of the parish'; and Woodman's Covert recalls former residents Samuell and William Woodman, here in 1714.

FROME (RIVER)

Actually two rivers in the county of this name. One drains into the Severn near Fretherne and is listed as Aqua de Frome in 1248, the second meets the Avon at Bristol and is seen as Fromes in 950 and Frama in 1221. Both have identical origins in Pre-Welsh *from* and British *fram*, both leading to the Welsh *ffraw* and speaking of 'the *frair*, brisk' river.

FYFIELD

From Old English *fif-hid* and listed as Fishide in the twelfth century, this name tells us it was 'the estate of five hides'. A hide being an ancient measurement of land which, while often quoted as being equal to 30 acres, is impossible to quantify. It refers to the amount of land required to feed a family for a single year, however there are too many variables to suggest a measurement — the size of the family, the quality and productivity of the soil being the two major factors.

Chapter Seven

G

GLOUCESTER

The county town has a name found as Colonaie Glev in the second century, while Domesday records it as Glowecestre. This features to elements and sees a Celtic place name followed by Old English *ceaster*. It was long held that names ending in -cester or -chester were derived from Latin *castra* and meaning 'Roman station', however the Romans did nothing when it came to naming places and a far better element is the Saxon, for *ceaster* refers only to a 'Roman stronghold'. Here the Celtic place name means 'bright place'.

Earlier the Romano-British name for the place sees Colonaie Glev, where the same Celtic name is prefixed by the Latin element to describe 'the Roman colony for retired legionaires'.

The ancient street names of the county town reflect other aspects of its history. Religion features in the names of Abbey Gate, from the Abbey of St Peter's; Archdeacon Street was where the Archdeacons of Gloucester had property; Greyfriars was the site of the Franciscan House; The Cross was once known as High Cross and one of many crosses in Gloucester; and Monkleighton comes from Old English *munc-leac-tun* or 'the leek enclosure of the monks of St Peter's Abbey'.

Alvin Street was once Alvingate, a name meaning 'Aelfwine's gap'; Hare Lane is from Old English *here-strete* describing 'the military road'; Oxlease was cut on what was once 'the ox pasture'; Oxbode Lane was 'ox house'; Saintbridge was constructed at 'the bridge at the sandy place'; Tredworth was 'Trydda's enclosure'; and Tuffley comes from 'Tuffa's woodland clearing'. Baker Street is where the bakers of Gloucester sold their goods, Longsmith Street marks where 'the street of the smiths worked'; Castle Street is the site of Gloucester Castle; Dockham Ditch refers to the 'water meadow overgrown with dock plants'; Chequers Bridge refers to this as 'the chequered (or coloured) plot of land'; and Bearland refers to the 'bare plot of land' which was used for the cattle market at the Midsummer Fair.

Ladybellegate Lane remembers the wife of Sir Thomas Bell, a wealthy alderman of the city. The name of Pornhale is first found in 1342 when it is recorded as where fish were caught with the aid of an illegal weir. Lawday Ditch marks the site where the sheriff's court met on appointed 'law days' to discuss matters of the day; while Pitt Street was the site of a burial ground for felons who had been given the death sentence.

Above: Gloucester Docks

Right: Robert Raikes's House,
Gloucester

Bull Lane was name from the Bull Inn. In 1771 landlord Mr Hincks shared first prize in the (then) national lottery. He treated his customers to a share of his winnings, not only be offering them drinks on the house but also by wiping every slate clean.

Local inns of the city include the Pig Inn the City, a name featuring a play on words and a reference to the Gloucester Old Spot, an ancient domesticated strain of pig. Many pubs are named after cheeses, cheese being one of the oldest foodstuffs served in the local, Double Gloucester is the county's cheese which contains a high cream content resulting in a rich flavour.

Dick Whittington, famously three times Lord Mayor of London, was born in the county, hence the name of the pub here. Sir Colin Campbell was named in honour of the British field-marshal (1792-1853) best remembered for his role in the relief of the siege of Lucknow in India. The Welsh Harp shows an early owner had connections with Wales. Whitesmiths Arms shows a connection with metalworks, specifically either tinsmiths or, more often and as depicted on the sign here, polishers of finished metal goods.

The England's Glory public house was named after the famous matches which were produced in Gloucester by S. J. Moreland & Sons, later by Bryant & May, both matchbox and pub depict the image of the Victorian battleship HMS *Devastation*. The Gloster aeroplane powered by the jet engine of Sir Frank Whittle was the inspiration behind the name of the Jet and Whittle pub.

GLOUCESTERSHIRE

The basic name is exactly as discussed above, with the addition coming from Old English *scir* meaning 'district' and first referred to in the eleventh century.

GLYNCH BROOK

A tributary of the River Leadon, which it empties into at Staunton, is related to Celtic *glanic* and Welsh *glan* meaning 'pure'. Records survive from 972 as Andlang glencincg, from the early fourteenth century as An glenccinc, and in 1383 as Water called Glengh.

GORE BROOK

This water course has its confluence with the Dry Brook in East Dean. Although the earliest surviving record of this name comes from 1770 as Gor Brook, this name must have existed before owing to it coming from the Old English language. This tongue was spoken by the Saxons some fifteen centuries ago and had evolved to Middle English between the twelfth and the fifteenth centuries, and thus is a name much older than the eighteenth century. Gore Brook takes its name from one of two Old English words, this is either *gor* meaning 'filth, dirt' or possibly *gara* or 'gore of land'. In the latter case this would speak of a region alongside or near the brook, a gore is a roughly triangular piece of land formed by three roads meeting or, from an alternative viewpoint, a fork in a road.

GORSLEY

Coming from Old English *gorst-leah*, this name describes 'the woodland clearing where gorse grows'. Records have not survived from before 1228, when it appears as Gorstley.

GOTHERINGTON

Domesday's Godrington shows this to come from a Saxon personal name followed by Old English *ing-tun* and telling us it was 'the estate associated with a man called Guthhere'.

The Merecoombs takes its name from it being 'the boundary valley', a marker for the natural boundary. Chester's Elms grow on land associated with Thomas and John Chester of Cheltenham in 1563, while over a century earlier, in 1455, William Notyngham of Gloucester gave his name to Nottingham Hill.

One look at the Shutter Inn and it is easy to see why it was so named, for shutters are present on almost every window — although they are now permanently fastened open.

GRAN BROOK

A tributary of the Avon in Weston on Avon listed as Grenan broc in 1005 and Grandbrook in 1698. The name is from Old English *grene-broc* and describes the 'green brook', with the colour referring to the overgrown vegetation along its banks rather than the colour of the water.

GREAT WITCOMBE

The oldest surviving record of this name dates from 1220 as Wydecomb and tells us it was 'the wide valley' from Old English *wid-cum*.

GREET

A fairly common name, normally found as a minor place name. It comes from the Old English *greote* and means 'the gravelly place'. In the twelfth century it is found as Grete.

GRETTON

In 1175 we find this name as Gretona, itself from the Old English describing 'the farmstead or *tun* near Greet'.

GUITING POWER

Listed as Gythinge in 814, Getinge in 1086, and Gettinges Poer in 1220, this is an old stream name from Old English *gyte* meaning 'flood, torrent'. The addition refers to the possession by the le Poer family by the early thirteenth century.

Castlett Farm undoubtedly takes its name form 'the valley haunted by wild cats', these animals have not been seen anywhere in England since the last known specimen was shot in the north of England in 1849. While there is no record of the wild cat being in this area there can be no doubt this is the creature being referred to. The wild cat, also called the Scottish wild cat, is famously untameable — indeed even when raised from the youngest kittens by hand they soon become impossible to handle. The resemblance to the domestic tabby has led to suggestions that this was the ancestor of the domestic cat, however genetic tests have shown the true ancestor to be the sand cat.

With the land around here predominantly agricultural, the naming of the Farmer's Arms public house was almost inevitable.

Chapter Eight

H

HAILES

Listed as Heile in 1086 and Heilis in 1114, this is most likely derived from an old stream name, a Celtic name referring to 'the dirty stream'.

From Old English *pisu-leah-graf* comes Peasley Grove and describing 'the grove near the woodland clearing where peas grow'; Groveleys is from *graf-laes* or 'the copse of the meadow'; and Ireley Farm began life as a settlement known as 'Ira's woodland clearing'.

HAM

This name features the common Old English element *hamm*, usually found as a suffix. It is recorded as Hamma in 1194, and describes the '(place in) the land hemmed in by water'.

Ironically the place name, which is derived from its location by water, gave its name to the brook of Ham Brook and listed as Hembroc in 1221. This is not the same watercourse as the following name but a tributary of the Chelt which it meets at Charlton Kings.

Appleridge Farm is still easy to see as 'the apple tree ridge'; Bevington was once a separate settlement known as 'the farmstead associated with a man called Beofa'; Clapton Farm was 'the farmstead near a hill'; and Hystfield began life as 'Hyssa's open land'.

HAM BROOK

The only record of note for this name is Hanbroc in 1086, it comes from the Old English *han-broc* and describes 'the brook by the stone'. The stone in question was almost certainly a boundary marker, but could possibly indicate an outcrop of rock which changed the course of the river.

HAMFALLOW

The name is first found in 1425 as Hameffolowe, which reveals this was 'the ploughed land of a man called Ham'.

Locally we find the names of Acton Hall, derived from 'Ecga's farmstead', and Agham Moor, from 'Ecga's water meadow'. Clearly these two places have a common beginning and doubtless refers to the same person, however it is interesting to note how differently the two have evolved.

The Actrees comes from Old English *ac-treow* and speaks of the '(place at) the oak trees'; Mobley is from *mapuldor-leah* or 'the clearing near the maple tree'; Walgaston Farm from *welm-gaers-tun* meaning 'the meadow with a spring'; while Tintock Wood is a much later name, from Early Modern English *tint*, the name describes the outline or the places as 'forked'; and finally Goody Hill, a surname found in a document from 1575 as Good.

HAMPNETT

Listed in Domesday as Hantone and as Hamtonett in 1213, this comes from Old English *heah-tun* and refers to the 'high farmstead'. The thirteenth-century record shows the addition of the Old French *ette* meaning 'little' and an indication of the Norman French influence.

HANHAM

Listed in Domesday as Hanun, this Old English place name refers to the '(place at) the rocks'.

Here we find Bickley Wood, ironically named after the clearing within the wood and referring to 'the woodland clearing with a bees' nest'. Longwell Green takes its basic name from Old English *lang-wella* or 'the long stream or well'.

HARDWICKE

From Old English *heorde-wic*, this place name refers to the 'herd farm, the farm for livestock'. It is recorded as Gerdewike in the twelfth century.

Acklow began life as 'Alca's woodland clearing', exactly the same origin as Hockley Hill although the two appear unrelated today. Persh Bed features the Old English *persc* or 'osier'; *Craig Y Nos* is modern Welsh and refers to 'the night rock' where a beacon would have been lit; and Field Court takes its name from the Field family.

The Pilot is a pub standing on the Gloucester and Sharpness Canal, a reference to those who pilot a kind of boat or ship.

HARE LANE

A road which has existed since the time of the Romans, and it is the forces of the empire which gave a name to 'the military highway'. Derived from Old English *here-paeth* or

here-weg the Roman roads were the result of existing pathways being surfaced and producing a hardwearing and resistant surface, with excellent drainage which saw the rapid and efficient movement of large numbers of soldiers deployed at what was then breathtaking speed.

HARESCOMBE

Recorded as Hersecome in 1086 and as Harescumbe in 1294, this name has never been really understood but is thought to represent the '(place at) Heresa's valley'.

Minor names include the unusual Scottsquar Hill, which has simply taken Old English *sceot* or 'steep slope' and added a modern element telling of the number of quarries in the area. Bacchus is another unusual place name, nothing to do with the Roman god of wine but a corruption of Old English *baec-hus*, still easy to see as meaning 'bake house'. Sparrow Farm was worked by the family of Richard Sparrow in 1747 and Joanna Sparrow in 1756.

HARESFIELD

A place name recorded in Domesday as Hersefel and in 1213 as Hersefeld, and which comes from a Saxon personal name followed by the Old English *feld* and speaking of 'the open land of a man called Hersa'.

Colethrop is named for being 'the outlying farmstead of a man called Cole'; and The Bulwarks points to 'the steep bank of an ancient encampment'.

HARNHILL

With the earliest forms limited to Domesday and Harehill, the first element here is uncertain. The definition which would be most obvious is from Old English *har-hyll* or 'the grey hill', yet the form fits the origin of *hara-hyll* and 'the hill frequented by hares'. Further information would be required to clarify this etymology.

Field names here include Old Gore from *gara* and 'triangular plot of land'; and Stanks Shadwell from *sceadu-wella-stank* or 'the corner of land with the spring fed pool'.

HARTPURY

This is an Old English place name from *heard-pirige* and describing 'the pear tree with hard fruit'. It is recorded as Hardepiry in the twelfth century, most likely named as a derogatory term by someone as a warning to others.

The Watersmeet Inn is aptly named, for it stands alongside three lakes and offers customers the opportunity to hire a boat and fish these waters. The Rising Sun is a welcoming sign, but was originally taken from the coat of arms of many landed families, including Edward III and Richard III.

Coopeys Farm took the name of the Coopers Arms beer house which was here around 1840, it taking the name of an earlier resident by the name of Cooper. Woolridge has nothing to do with sheep but means 'the beetle infested ridge'.

HASFIELD

From Old English *haesel-feld* and recorded in Domesday as Hasfelde, this place has a name speaking of 'the open land where hazels grow'.

Scarifours has been suggested to be from 'scare fire', that is a sudden fire and a reference to a single event in the history of the place. However it seems more logical for it to be an early record of 'to scarify' much the same as removing moss and grass cuttings from the most cherished lawn, in which case it could be tending or weeding a small kitchen garden or croft.

HATHEROP

A name meaning 'the high outlying farmstead', which comes from Old English *heah-throp*. Only one early form has been found, as Etherope in the Domesday record of 1086. The name of Croft Pingle features two common Old English elements featuring in field names across the country, the elements have changed little since Saxon times when croft and pingel referred to 'the small enclosure'.

Barrow Elm is a reminder that Hatherop once enjoyed higher status than it does today. Saxon England was divided into administrative regions known as hundreds, a division which was still in use in many parts of England right up to the Victorian era. Hatherop was a part of the Brightwells Barrow Hundred, indeed it was the meeting

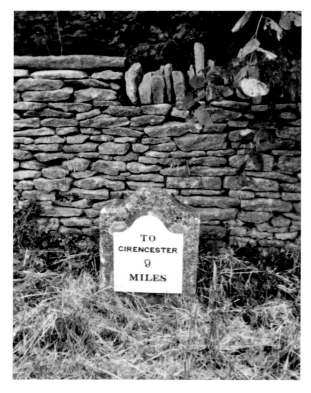

Hatherop milepost

place for the area sitting at the crossing point of the roads from Fairford to Hatherop and Lechlade to Barnsley. Crossroads were natural sites for tumuli or barrows, and one of these burial mounds is found here. Furthermore it once had a large and prominent elm tree growing on the top of the low flat-topped burial mound, hence the name.

HAWKESBURY

Domesday records this name as Havochesberie, a name which has two possible meanings. If the basis is Old English *hafoc-burh* then this is 'the stronghold of the hawk', however the first element here may represent a personal name and therefore would be 'Hafoc's stronghold'.

What was once the Duke of Beaufort public house is now the Beaufort Arms. The duke held the title of Master of the Hunt and, since his death in 1984, the hunt has been banned in England. So as not to alienate potential customers opposed to hunting, the name changed.

HAWLING

With only Domesday's record of Hallinge to work with, it is difficult to discern between the three possible origins for this name. One theory suggests these people migrated here from Hallow in Worcestershire, in which case this would describe 'the settlement of the people of Hallow'. Yet it is also possible that this place name merits the same description of that of Hallow, from *halh-ingas* and 'the settlement of the people at the nook of land'. Alternatively this first element may be a personal name, from 'the settlement of the family or followers of a man called Heall'. Further evidence is required here.

Shewell Hill is a name which is unlikely to be found far from the Gloucestershire area, for it features the dialect term *shewel* meaning 'scarecrow'.

HAZLETON

Records of this name are found in Domesday as Hasedene and the twelfth century as Haselton. This is a name from Old English *haesel-tun* and describing 'the farmstead where hazels grow'.

The name of Puesdown is a Saxon name describing 'Peofel's dun or hill'.

HEMPSTED

Listed as Hechanstede in Domesday, this place is 'the high homestead' from Old English *heah-ham-stede*. This is a quite commonplace name which would normally be expected to have a second distinctive name.

Netheridge aptly describes itself as a 'strip of land between two streams'; Newark Farm was 'the new building or fortification'; and Podsmead known as 'Podd's meadow'.

HENBURY

This name is recorded in 682 as Heanburg, which comes from Old English *hean-burg* and describes 'the high fortification'.

Brentry comes from 'the tree of Beorna'; Elmington began life as 'the farmstead associated with a man called Athelmund'; Hallen is derived from *halh-ende* or the 'end of the nook of land'; and Hung Road was 'where ships ride at anchor'.

HEWELSFIELD

From Domesday comes the name of Hiwoldestone which had evolved to Hualdesfeld by 1145. Undoubtedly this is 'open land of a man called Hygewald', with the personal named followed by Old English *feld* and previously *tun*.

HIDCOTE BARTRIM

The parish also features the place name of West Heys, a name from Old English *uferra-gehaeg* and referring to 'the upper enclosure'.

HIDCOTE ROYCE

Records of this are found as Hudicota in 716, Hedecote in 1086, and Hudicote Boys in 1327. The basic name here comes from Old English *cot* prefixed by a Saxon personal name and is 'the cottages of a man called Hydeca or Huda'. The addition here seems a little superfluous, for there are no similar place names anywhere near here. Perhaps this is the work of an egotistical lord of the manor, and yet perhaps they should have ensured the name was recorded properly for there is evidence of a de Bosco family and a Bois family during the thirteenth century.

HIGHLEADON

A name not found before the thirteenth century as Hineledene, this name refers to 'the estate on the River Leadon of the religious community'. It is derived from two elements, Old English *hiwan* and a Celtic River name meaning 'the broad stream'.

HIGHNAM

Domesday records this place as simply Hamme, an Old English element meaning 'water meadow' and usually found as the suffix in a name. However the next record we have gives the name as Hinehamme, which adds Old English *hiwan* or *higna* and informs us this was a religious community. It is tempting to suggest Domesday's record is in error, and yet there is no record of any religious site here until that of the place name.

Locally we find Linton, once an independent settlement which was 'the farmstead associated with a man called Lilla'.

HILL

Domesday records this as Hilla, and it is from the Old English *hyll*, although it should be interpreted as referring to the settlement and thus the '(place at) the hill'.

Cobb's Hole was the site of the home of Rebecca and Mary Cobb in 1665. Dry Warth comes from Old English *waroth* and describes the 'shore' or bank or the river. Bannutt Tree Patch is clearly a tree, a tree which would have been sought for its fruit, for this is a dialect term for a walnut tree.

HINTON

A common place name and one which is derived from Old English *heah-tun* 'the high or chief farmstead'. It is first seen in the thirteenth century as Heanton.

Cotterday Hole takes its name from Old English *cot-worthig* 'the enclosure with a shed or cottage'. Saniger Farm comes from *swan-hangra* which could be either 'the herdsman's wood' or the 'swans by a wood'. Sharpness was once 'Sceobba's headland'; and Waveridge Sand the 'shifting or unstable sandbank' in the River Severn.

HOLY BROOK

Such a name must refer to this stream being the site of a Christian rite, possibly even one which previously was a pagan ritual. The name is recorded as Hollowwell in 1609 and Holywell in 1658 and comes from Old English *halig-wella* and giving 'the holy spring or well'. This is a tributary of the Frome which it meets at Bisley.

HORSBERE BROOK

A brook which runs into the Severn at Longford and is listed as Aquam Horsbere in 1243 and Horsbeyrebrigg in 1363. Here is an Old English name from *hors-bearu-broc* and meaning 'the brook of or by the horse grove'.

HORSLEY

Recorded in Domesday as Horselei, it does refer to 'the woodland clearing where horses are kept'. The name is Old English from *hors-leah*.

Minor names in Horsley include Chavenage House meaning 'Caefa's enclosure'; Ledgemeore Bottom and Ledgemore Pond and referring to 'Lud's marshland'; Nupend is 'the upper end (of the village)'; Bittums is a common name in the county, which comes from *bytme* or '(at the) bottoms'; Fire Shovel is a field name taken from its shape; and Harmers a name referring to 'a pool of filth'.

The Bell and Castle unites two instantly recognisable images. Yet while the Bell undoubtedly refers to the parish church of St Martins, the castle comes from the coat of arms of the landholder.

HORTON

An Old English place name which is recorded in Domesday as Horedone, indicating this is not the usual meaning. This is from *heorot-dun* and 'the hill frequented by harts or stags'.

One descriptive place name is that of Totteroak, which literally speaks of the 'tottering or unsteady oak tree'. Place names often have to be in use for some time before they stick and thus it makes one wonder how unsteady and for how long this oak tree was allowed to stand, for there was clearly an element of danger involved.

A second tree name is that of Bodkin Hazel Wood, where the hazel trees grew on 'Beaduca's hillock'. Other individuals of Horton's past have left their mark on the landscape: Piper's Trench remembers the Piper family who were here in 1575; Pulling's Trench was associated with the Pullen family of 1722; Longs Trench recalls Daniel Long in 1764; and Ragnel Trench was home to the Ragnall family in 1838. This is not the trench which we would envisage, the term refers specifically to a ride cut and maintained through woodland.

HOUGHTON BROOK

Actually two streams, the Great Houghton Brook and Little Houghton Brook, both tributaries of the Lyd Brook in East Dean and West Dean respectively. This basic name is derived from Old English *hol-broc* 'the stream in a hollow', the streams being at opposite sides of the main valley.

Any river name is given by those living or crossing its course at a single point, thus the name is relevant to that particular point and often does not fit elsewhere along the river. Thus although we will never know who named the place it is sometimes possible to see where the name was applicable and here is just such an example. For both tributaries to share a name they were almost certainly named by the same peoples, and the most logical place for that settlement is between the two rivers, possibly even just upstream of the confluence of the two. The names are recorded as Holebrok in 1282 and Hoebrooke in 1612.

HUCCLECOTE

Found in Domesday as Hochilicote, the 'cottages associated with a man called Hucel or Hucela' features a Saxon personal name ahead of Old English *ing-cot*.

Elm Bridge may be obvious as being built where 'elm trees grow', however Zoons Court is a little harder to see as from Old English *sund* meaning 'wet and sandy'.

HUMBER BROOK

A river course which empties into the Stour at Preston-on-Stour. Despite the only surviving records of this name being Humber ffilde in 1575 and Humber Brooke in 1642, the name comes from the Celtic *sumbr* from at least the Roman era and probably even before the arrival of the empire in Britain. This speaks of this river being 'the good one', and describing it having many desirable elements.

HUNTLEY

From Old English *hunta-leah*, and recorded in Domesday as Huntelei, this place name tells us it was 'the huntsman's woodland clearing'.

Baker's Dole is a local name referring to the association with the Baker family of the Dole or 'share of land'.

The Huntley Stocks

Chapter Nine

I

ICOMB

Records of this name include Iccacumb in 781 and Iccumbe in 1086. This comes from the Old English *cumb* following a personal name and describes 'the valley of a man called Icca'.

Within the parish we find Dustlett Wood, which takes the name of 'the deer valley'; while Guys Tower occupies the site of the house of Thomas Guy who was here in 1619.

IRON ACTON

Listed as Actune in 1086 and as Irenacton in 1248, this features one of the most common of English place names from Old English *ac-tun* or 'the farmstead by the oak trees'. Invariably such names have a second element, here it is Old English *iren* and a reference to the old ironworkings.

Latteridge derives its name from *lad-denu* or 'the water course valley', while Mudgedown began life as 'Modwulf's hill'.

ISBOURNE (RIVER)

Records of this name are plentiful, appearing as Esenburnen in 709, Esegburna in 777, Esingburnan in 930, and Eseburne in 988. It is difficult to discern between the definitions of 'Esa's stream' and 'the stream of Esa's people'. The Isbourne flows into the Avon at Hinton on the Green.

ITCHINGTON

Found as Icenantune in 967 and Icetune in 1086, this place features an ancient, pre-Celtic river name of unknown meaning and the Old English *tun* or farmstead.

Chapter Ten

K

KEMBLE

Records of this name include Kemele in 682 and Chemele in 1086, which shows this to be a Celtic place name meaning 'border, edge'.

Minor names here include Smerrill Farm, referring to the 'hill rich with fat-producing pasture' and pointing to this being a successful dairy farm; while Lamas mead is a reasonably common field name used to describe a 'pasture available from Lammas', a Catholic festival also known as loaf-mass day and celebrated 1 August, and traditionally when a loaf of bread was made from the first cut of wheat of the season.

The Tavern Inn is an odd name, for why would a pub be both a tavern and an inn? There is no real difference between them and there is no explanation for the name.

KEMERTON

Found as Cyneburgingctun in 840, this is a Saxon personal name followed by Old English *ing-tun* and describes 'the farmstead associated with a woman called Cyneburg'.

At Kemerton is the Banbury Stone, a feature which is named from the 'fortified place of a man called Baening'.

KEMPLEY

Listed as Chenepelei in 1086 this name is most likely from 'Cenep's woodland clearing' and where the Saxon personal name is suffixed by Old English *leah*.

KEMPSFORD

A place name which means 'the ford of a man called Cynemaer', it is recorded as Chenemeresforde in Domesday and as Cynemaeres forda during the ninth century, a form which is almost exactly like that of the original name.

Minor names here include Whelford or 'the ford at the deep pool'; Dudgrove Farm takes its name from an old settlement known as 'Dudda's woodland grove'; Stubb Barn

was constructed on a site of Old English *stubb* or 'tree stumps'; Thursditch seems to be a remnant of local mythology, for Old English *thyrs* means 'giant, or demon'; and finally Picked Lease, of comparatively modern origins in an Early Modern English *piked* with Old English *laes* and describing the shape of a 'pointed cleared area'.

KILCOT

Found as Chilecot in Domesday this name comes from a Saxon personal name followed by Old English *cot* and describing 'the cottages of a man called Cylla'.

KINETON

Derived from Old English *cyne-tun*, this is recorded as Kinton in 1191 and speaks of 'the royal manor' (literally the king's *tun*).

KINGSCOTE

Listed as Chingescote in 1086 and as Kengescota in 1220, this name comes from Old English *cyning-cot* and describes 'the cottages of huts of the king's land'.

Hazelcote sounds idyllic as 'the cottage by the hazel trees', although Cold Harbour sounds less welcoming as 'the cold or inhospitable inn'.

KINGSWOOD

Here is a name which is self-explanatory for indeed this is 'the woodland on the king's land'.

Locally we find Elbury Hill, the 'camp among the elder trees'; the name of Conham refers to 'Cana's homestead'; and Nind Farm takes its name from Middle English *atten-ende* or 'the place at the ende of land'. Luggers Hill is a name painting a detailed picture of the area as it was around the time before the Norman Conquest, for this refers to 'the nook of land with a spear trap'.

KINGS STANLEY

Found in Domesday as Stanlege and in 1220 as Kingestanleg, this name comes from Old English *stan-leah* and refers to 'the stony woodland clearing' with the addition referring to it being the property of the Crown. This was also the reason for the naming of the Kings Head.

Peckstreet Farm takes its name from Old English *peac* or 'peak', while the road known as Pen Lane leads to Pen Hill. Robin Reddocks Castle seems to be a personal name, whereas it is simply 'the fortified place where robins are often seen'.

KINGSWOOD

Listed in 1166 as Kingeswoda, this name comes from the Old English *cyning-wudu* and describes 'the king's wood'.

KNEE BROOK

The earliest surviving record of this name is as the modern form, dating from as recently as 1830. However the name is certainly much older than this for it comes from the Old English or Saxon *cneow-broc* and describes 'the bend (or knee) in the river'. This is a perfect description of the winding course of the Knee Brook, particularly by the aptly-named Knee Bridge taking the Fosse Way over its course.

Prior to the arrival of the Normans there is a record of this river as Doferburna, which features British *dubro* or Welsh *dwfr* meaning 'water' together with Old English *burna* or 'stream'.

Chapter Eleven

L

LADDEN BROOK

Recorded as Loden in 1540 and West Laddon in 1592, this watercourse runs into the Frome at Iron Acton. This is an Old English river name from *lad* and here meaning 'watercourse', although it is also used to mean 'road' and thus should probably be defined as 'route'.

LASSINGTON

Recorded as Lessendune in 1086 and Lessendon in 1265 and is possibly 'the farmstead associated with a man called Leaxa'.

LATTERIDGE

A Saxon place name with no surviving records before that of 1176 as Laderugga. Here the Old English elements have combined in *lad-hrycg* and given 'the ridge by a watercourse'.

A Latteridge signpost

LAVERTON

Listed as Lawertune around 1160, this name comes from Old English *lawerce-tuna* and describes 'the farmstead frequented by larks'.

LEACH (RIVER)

As examined under Eastleach this river is unusual in having a Saxon or Old English etymology which is not from a place name. Here the element *laecc* describes the 'stream flowing through boggy land'. This is not as obvious as it may seem, for the name shows that few streams spread outside their banks all year round and this reference to a marshy region would have made this recognisable.

A name such as that of the Leach is different from a great number of Celtic names in that it refers to a particular part of the river, while most Celtic (or pre-Celtic) names refer to the river itself — its flow, colour, etc. This is undoubtedly another reason why there are so few Saxon river names. However it does raise the point that, if the description only refers to one point on the whole river, how did the name become taken for its entire length? The answer is simply sheer luck.

The most common way the name was given to the entire river was from it being marked as such on a map, and the cartographer must have researched the name of the river and thus the name came from one part of its length — that part being exactly where the question of its name was raised for if there was no 'boggy land around the stream' at a particular point then the name of Leach or *laecc* could never have been coined.

It also raises the question of what other names the river has been known by — other contemporary names elsewhere along its course and earlier names — however these are now lost and will probably never be known.

LEADON (RIVER)

Unlike the previous name this is derived from the Celtic or British tongue and, as we would expect, describes the stream and not a particular point along its course. Here this is quite simply 'the broad stream'. It has given its name to Highleadon which stands on its banks.

LECHLADE

The highest navigable point on the River Thames takes its name from the River Leach, the conflence of the two rivers being nearby. For those who have never encountered the name, and have no knowledge of its origins, it is almost certain they will mispronounce this as 'leck-' when it should be 'letch-'. Here the name is derived from Old English *laecc-gelad* and describes 'the river crossing near the River Leach', and is recorded in Domesday as Lecelade.

Within the parish we find Bryworth Farm or 'Brega's (possibly Broga) enclosure'; Downington describes the 'part of the village at the lower end of Lechlade Down' and is from Old English *dun-ende-tun*; Butler's Court has a basic name which started life

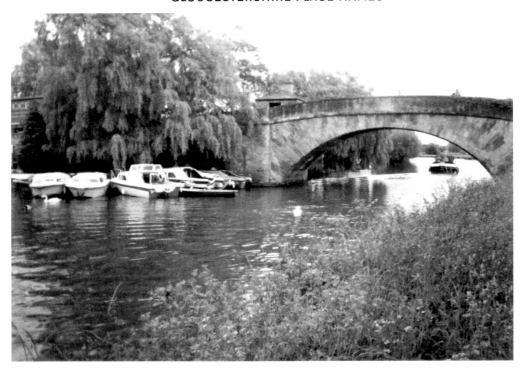

The River Thames at Lechlade

as 'Boteler's Hall'; Pest House was, in Elizabethan times, 'the hospital for infectious diseases'; while Trouthouse Farm took its name from the former pub here, the Trout Inn.

Field names of Lechlade are not always complimentary. The Brickbats comes from *brickle-bat* 'the brittle pieces of rock' and not the greatest place to attempt to grow crops. The oddly named Quack Hill is from Old English *cwacian* meaning 'to quake or tremble', not suggesting localised earthquakes but the likelihood of landslip or subsidence. From Old English *lythre-hamm* comes the name of Letherham, hardly desirable agricultural land as this is described as the 'bad or worthless water meadow'. Rats Castle is a jocular term for a building which, while it may have the odd rodent, is merely a derelict building.

Finally there is Cuckoo Pen, an enclosure for livestock which seems to have been a derogatory term, possibly describing a poorly made or impractical fence. It is a name common to neighbouring Oxfordshire and comes from the tales of the Wise Men of Gotham, a collection of narratives retold as coming from Gotham in Nottinghamshire. The Tale of the Cuckoo is probably the best known and centres around the villagers' desire to hear the song of the best-known British migratory bird every day of the year. Thus the men built a fence around the bush to trap the cuckoo, only to watch as the bird flew up and over the new fence, whereupon the men deduced they would have succeeded had they but built the fence a little higher.

There are various explanations as to the origins of these stories, including political satire. Legend has it that the stories were first retold as originating in Gotham in the

A Lechlade signpost

early thirteenth century, when King John was contemplating setting up home in Gotham and despatched royal messengers to the village in order to ascertain the suitability of the place for a royal person. John Lackland, as he was also known, was not the most popular of rulers and the village could readily imagine how their lives would be in turmoil with the arrival of King John and his entourage. Thus they appeared fools and imbeciles to the messengers and, returning to the king with news of the worthless inhabitants, made the king think again about the siting of his home. It is said the villagers, now known to travellers to be of little brain, would respond to the barbs and insults with 'There are more fools pass through Gotham than remain in it'.

LECKHAMPTON

A name first recorded in Domesday as Lechametone comes from Old English *leac-ham-tun*. Here is an excellent description of how the Saxon settlement specialised in one crop, for this was 'the home farm where leeks are grown'. Leeks are rarely mentioned in place names and yet we know that, along with members of the cabbage family, they were almost an obligatory ingredient in Saxon dishes and demand must have been assured.

Locally are found The Bittarns meaning 'the head of the valley' and describing the brook which is a tributary of the Chelt; and Collum End Farm, a corruption of 'the land of the meadow where charcoal is produced'.

Eynon Close is named after Canon Ettrick Eynon, vicar of St Philip and St James. Hillary Road was developed shortly after the conquest of Everest and named after Sir Edmund Hillary who was one of the two men who climbed the world's highest mountain.

LEIGH

From Old English *leah* or 'woodland clearing', this features an element usually only found as a suffix. This name is recorded as Lalege in 1086 and as Leg in 1260.

Minor names here include Evington or 'the farmstead associated with a man called Geofa'; Stain's Bridge is probably 'the stony bridge' despite the appearance of a family name; and Brand Oak is a marker, a 'burned oak' which would have stood on a route for many years.

LEIGHTERTON

A name not recorded before twelfth century, when it is found as Lettrintone. This is from Old English *laehtric-tun* and another unusual name for it is describing 'the farmstead where lettuce grows'. Which also tells us there was a demand for this salad vegetable, although one doubts the use was anything like that of today.

The local pub is the Royal Oak, named after the famous tree at Shifnal in Shropshire where Charles II and Colonel Carless hid from the Parliamentarians who had pursued them following the Royalist defeat at the Battle of Worcester in 1651. It is still the second most common pub name in the land.

LEONARD STANLEY

A name recorded in Domesday as Stanlege and in 1285 as Stanllegh Leonardi, the name speaks of this as 'the stony woodland clearing' from Old English *stan-leah*. The addition, to distinguish from King's Stanley, refers to the dedication of the church to St Leonard.

The field name of Clails comes from Old English *claeg-halh* and describes 'the clayey nook of land'. The White Hart Inn is an heraldic image which was first used to mark the reign of Richard II.

LITTLEDEAN

Domesday says this was known simply as Dene in 1086, which by 1220 had become Parva Dene. Here the Old English *denu* or 'valley' has the addition of Latin *parva* 'little' to distinguish it from nearby Mitcheldean.

LITTLE SODBURY

This 'fortified place of a man called Soppa' is smaller than Chipping Sodbury as we would expect.

Here is Ball's Cottages, which took the name of Hannah Ball of Tetbury on the occasion of her marriage in 1684.

LITTLETON UPON SEVERN

Anyone who thinks of the possible origin of place names will not be surprised to find this is 'the little farmstead on the River Severn'. The long and complex origins of the River Severn are discussed under its own heading, but the first element here is from Old English *lytel-tun* and is recorded as Liteltone in 1086.

Locally we find Stonage Field or 'the stoney bank', and Rushen Gout which features the Early Modern English gout and describes 'the water channel overgrown with rushes'.

LONGBOROUGH

Listed as Langeberge in 1086, this Old English *lang-beorg* tells us it began life as 'the long hill or barrow'.

Within the parish is Banks Fee, a name which features Middle English *fe* or 'landed estate' and which was recorded as belonging to Richard de Blanck in 1287. Frogmore Farm is derived from Old English *frogga-mor* or 'the frog infested marshland'; Luckley Farm is from 'Luca's *leah* or woodland clearing'; Saltmore Coppice is from *salt-mor* and refers to 'a mark on the saltway' and thus a guidepost for these most ancient of traders. Stratford Bridge takes its name from Old English *straet-ford*, the bridge allowing the passage of a mile-long track to the Fosse Way across the Evenlode and thus the name means 'the ford to the Roman road'. Horsington Covert is most likely from *hors-dun* 'the hill where horses are seen', although the element *ing* would normally follow a personal name and yet this seems to be an error for there is very few examples of the personal name Horsa.

The Coach and Horses reminds us of the days when pubs were the stopping points for travellers.

LONGFORD

From Old English *lang-ford* and recorded as Langeford in 1107, this is indeed 'the long ford'. Often such names are debated as to whether this refers to the distance one has to traverse in order to cross the stream, or if it is a wide ford and thus crossable along a long stretch of the river. The main problem in answering this question is that today the original river crossing is unrecognisable and thus unanswerable.

Hereabouts we find the name of Pedmarsh, which has changed little since it Saxon times when it was 'Peada's marsh'; while Walham could either be 'the water meadow of the Welsh' or 'water meadow of the serfs'.

LONGHOPE

A name recorded in 1086 as simply Hope had become Langahope by 1248. This is from Old English *lang-hop* and describes 'the long valley'.

The name of Bearfoot Wood would be understood as 'barefoot' orally, indeed it is surprising the name has not become corrupted as bare- and not bear-. This name does not refer to any ursine paw print either, indeed bears were extinct in Britain well before the time this name existed. Early Modern English *berefot* refers to the 'hellebore', a group of plants which are often referred to as a Christmas Rose or sometimes Lenten Rose, although these plants are not related to the rose.

LONG MARSTON

A name found in 1043 as Merstuna and in 1583 as Longe Marston. This is the 'farmstead near a marsh' which takes the addition to refer to its shape.

Locally we find Court Farm, where the manor house once stood; Ox Close, where the plough team were pastured; and Shepherds Close, home to the local shepherd.

LONG NEWNTON

Early records of this name include Niuentun in 681, the addition not seen until 1585 as Longnewnton. Here is 'the new farmstead' with the addition 'long' referring to how the houses are strung along the lane rather than around a central point.

LONGNEY

Two early records of note here, as Longanege in 972 and as Langenei in 1086. This is derived from Old English *lang-eg* and refers to 'the long island'. To the Saxons an island was not necessarily surrounded by water and certainly not permanent water. Indeed more often than not the reference is to a region which will remain dry other than in exceptional circumstances, and is where the settlement is situated, while much of the surrounding area is marshy or simply seasonally boggy.

Of the many Gloucestershire place names that of Madam must be among the most unusual. It comes from the Saxon for 'Mada's water meadow'.

LOWER LEMINGTON

Domesday records this place as Limentone, itself thought to be from a Celtic river name with Old English *tun* and referring to 'the farmstead on the stream known as the Limen', itself describing the 'elm tree river'. Unusually while the river name is known and understood, the river itself is no more for changes in the landscape have deprived it of its water.

Minor names here include Oldborough Farm, takes the name of an old settlement. Derived from Old English *ald-burh* this name refers to 'the old fortification', which also shows that the place had already been abandoned when the main settlement started to grow.

LYDD (RIVER)

A stream which takes its name from the village of Lydney (see below), a process known as back-formation. It is still also referred to as the Cannop Brook, a name which refers to 'the rounded hill' and hence this alternative name would refer to 'the stream of the rounded hill'.

LYDNEY

Found in 853 and 1086 as Lideneg and Ledenei respectively, this name comes from Old English *lida-eg* and tells us this was 'the island of the sailor'. Alternatively the first element may be the personal name Lida.

Within the parish boundaries we find Dodmore Wood which is derived from 'Doda's marsh', while Curves Hill is derived from Old English *cyrf* and meaning 'cutting'.

Pubs here include the aptly named Severn View. The Miners Arms remembers this was where the canal served to ship coal excavated in the Forest of Dean. The Annexe Inn was built alongside another building, yet is not actually connected to it. The Fountain Inn is often associated with nearby springs or wells, yet most refer heraldically to either the Plumbers Company or the Master Mariners.

Chapter Twelve

M

MAISEMORE

Found as Mayesmora in 1138, this name comes from Welsh *maes-mawr* and describes 'the great field'. Perhaps we should say it comes from Celtic, or is related to Welsh, for otherwise it gives the impression of being the abode of Welshmen and, although this is not impossible, it does perhaps give a misleading impression. Indeed it should be noted that, to a Saxon at least, a Welshman was simply a foreigner.

MANGOTSFIELD

The only early form of note comes from Domesday as Manegodesfelle. This shows it is an Old German personal name with Old English *feld*, speaking of 'the open land of a man called Mangod'. Often it is hard to distinguish between Saxon and German names, indeed it is quite possible that many names said to be Saxon may well have been a German. Here we are certain this is a German name and which, almost certainly, tells us this was a man who was living with the Saxons who came from the north of the Germanic tribes.

 The name of Staple Hill is from Old English *stapol* meaning 'post, pillar', which would have been a marker for a meeting place, a boundary, or similar.

MARCHFONT BROOK

A stream which joins the Avon at Clifford Chambers and one with a name which must be one of the most obscure. It certainly sounds like a family name and would have migrated across from Norman France. However no record links to any potential origin and thus remains unknown.

MARSHFIELD

A name which has two possible origins, although the obvious one of *mersc-feld* of 'the marshy open land' is the least likely simply because it would be naturally bad

farmland. Thus the popular beginnings are said to be *maere-feld* or 'the open land on the boundary'.

Ashwick Grange and Ashwick Hall take the name from Old English *aesc-wic* or 'the dairy farm near an ash tree'. Ayford Bridge was constructed near 'the ford by an island', and Cloud Wood comes from Old English *clud* or 'mass of rock'.

MATSON

A name meaning either 'Maethhere's or Mattere's hill', this name is recorded as Mattresdone in 1121 and as Matesden in 1221.

Robins Wood Hill has avoided being among the many names which suggests a link to the legendary hero of Sherwood Forest, here the name has retained the description of the wood on the hill and refers to the tenants named Robin who took out a seventy-year lease on this land in 1526. The local pub took the name as the Robinswood Inn.

MAUGERSBURY

From 714 it is recorded as Meilgaresbyri and as Malgeresberie in Domesday, which is probably from 'Maethelgar's stronghold' where the Saxon personal name is followed by *burh*.

MEYSEY HAMPTON

Recorded as Hantone in 1086 and Meseieshampton in 1287, the basic name comes from Old English *ham-tun* or 'the home farm'. Here the addition is a manorial reference to the de Meisi family, here from the twelfth century.

Two Old English field names of note here, predictably Shire Ditch tells us it is 'the Wiltshire border ditch', while Lip Yat is a somewhat unexpected corruption of Old English *hliep-gaet* or 'the leap gate' and where a particular section of the fence or hedge provided an effective barrier to livestock but could easily be cleared by deer.

The Masons Arms may not have been owned by a member of the ancient trade but was likely named as a meeting place for the Freemasons, a society of individuals renowned for their charitable work.

MICKLETON

A quite common name found in many of the counties of England and, although there are exceptions, does mostly come from Old English *micel-tun* or 'the large farmstead', The name is documented in 1005 and 1086 as Micclantun and Muceltvne respectively.

Locally we find Baker's Hill, named after the family who lived here including Anthony Baker in 1619 and William Baker in 1670; Nineveh, a surprisingly common name and always a Biblical reference transferred for many different reasons; and Spelsbury Barn from Old English *spell-beorg* or 'speech hill'. This last name is found on the highest local point of the Cotswold Escarpment, furthermore it is next to Kiftsgate Court which

took the name of the Kiftsgate Hundred and was the meeting place for such, hence the name.

MILCOTE

A name found as Mulecote in 710 and as Mulcote in 1330, this comes from Old English *myln-cote* and means this was the '(place at) mill cottage'.

MINCHINHAMPTON

Domesday's record of Hantone is followed by Minchenhamtone in 1221. Here the original Old English *heah-tun* or 'the high farmstead' is prefixed by *myncena* which tells us it was a place 'of the nuns' and a reference to this place being owned by the nunnery at Caen in France from the eleventh century.

Local names here include the name of Amberley, a region which may come from Old English *amore* or 'the woodland clearing frequented by bunting', or it could be a personal name and 'Amber's woodland clearing'. Besbury Farm is another with two potential origins, either 'Beassa's stronghold' or from *be-eastan-byrig* or 'land to the east of the fortification'. Cowcumbe Hill and Cowcumbe Wood tell us it was 'the valley where charcoal was burnt', and a particular favourite of the author for it produces a snapshot of everyday life here in centuries past.

Minchinhampton Market House

Gatcombe takes its name from the 'gap valley'; Trullwell comes from Middle English *trowelle* and Old English *wella* and meaning 'the spring of the scoop' and a reference to the shape of the landscape here. Gydynap Lane leads to 'Giddy's cnaepp' or hillock; Littleworth is from *lytel-worth* and refers to this being 'the field of little value'. Theescombe takes its name from 'the valley haunted by thieves'; Shoulder of Mutton is a common field name in England, referring to its shape; Barcelona is the most distant corner of the parish and referred to by using what is termed as a remoteness name.

Woeful Lake takes its name from *wudu-pol-lac* and refers to 'the pool or lake by the wood'; Woefuldane Bottom and Woefuldane Farm are traditionally the site of a great battle between the Saxon *Wolphgang* and the Danish leader Uffa. St Chloe is an odd name, for it is a nothing to do with saints or religion at all but a mispronounced name referring to 'the clearing made by birds such as bunting'.

The Devil's Churchyard is an odd name, for there is no church here today. Locals have always known this as a place of evil, for it is said no birds are heard to sing in the trees here, and the darkness and chills are unnatural. When it was suggested that a church be built here it was welcomed, better than the walk to neighbouring villages to worship. When work started foundations were soon laid and the walls had risen to half the eventual height when the work finished for the day. Next morning the workers returned to find every stone removed and strewn around the site. The walls were repaired and again the walls had been taken down, this happened on four more times and resulted in the church being abandoned and the evil behind this mystery reflected in the name.

The Weighbridge Inn rather unkindly depicts a large lady tipping the scales at almost a quarter of a ton!

MINSTERWORTH

The only early record of note which has survived is as Mynsterworthig from around 1030. This is from Old English *mynster-worth* and refers to 'the enclosure of the monastery' — specifically St Peter's in Gloucester.

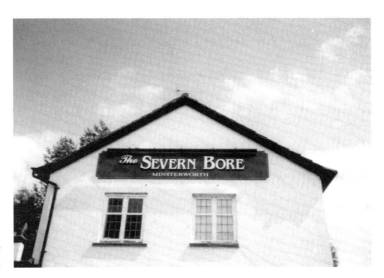

The Severn Bore public house at Minsterworth

The River Severn at Minsterworth

The Severn Bore Inn is one of the few places to take the name of the tidal bore with which the river is famously associated. The shape of the estuary and the Bristol Channel funnels the tides into the ever-narrowing river. This feature, added to a fifteen metre tidal fall (the second largest in the world), means the rise of the water actually exceeds that of the flow of the river and the bore flows upstream at sixteen kilometres per hour. The pub is one of the very few recommended viewing points for this fascinating phenomenon.

Murcott tells us it was 'the cottage on a marsh'; Cooke's Hill could refer to either of two former residents, Joseph Cooke was here in 1695 and Thomas Cooke in 1703.

MISERDEN

The records of this name show how, following the increasing Norman influence in England, the name of this place actually changed. The Domesday record shows this as Grenhamstede, reflecting the Old English *grene-ham-stede* and describing 'the green homestead'. At the time of the great survey the place was held by the Musard family and, in a document of 1186 exactly 100 years after Domesday, the name of the place is said to be Musardera or 'Musard's manor. Clearly the family were still influencing this place, which was now exhibiting an Old French surname suffixed by ere.

Minor names of note around Miserden include Bidfield or 'Byda's open land'; Sudgrove takes its name from 'the southern woodland'; Wishanger describes 'the wooded hill by a wet meadow'; Conigar is a corruption of the alternative name for a 'rabbit warren'; Goldwell Wood has nothing to do with precious metals but far more importantly 'the spring where marigolds abound'; and Lamphill Wood which points to a region which would have been worked by the community, all rent monies gleaned from this went to paying for the lamp or lighting in the church.

MITCHELDEAN

The name of this place clearly comes from Old English *micel-denu* or 'the great (place at) the valley'. Early records are interesting, for in 1224 this is shown as Muckeldine, while just four years earlier a document gives it simply as Dea. This would suggest that both names could well have been in use at the same time, the early one eventually giving way to the current name.

MORETON-IN-MARSH

A very commonplace basic place name which normally, as here, comes from Old English *mor-tun* and meaning 'the farmstead in marshy ground'. This name is recorded as Mortun in 714, as Mortune in 1086, and as Morton in Hennemersh in 1253. This last name features an addition which has since lost the first element. It is derived from Old English *henn-mersc* and speaks of 'the marsh frequented by wild hen-birds (possibly moor-hens or grebe)'.

The Inn on the Marsh is a predictable name taking advantage of the place name. The Swan Inn could refer to the bird yet most are heraldic, although which coat of arms it is taken from is impossible to say for it was adopted by so many families and institutions. The Black Bear is probably heraldic too, although it could refer to the barbaric bear baiting banned in the nineteenth century.

MORETON VALENCE

Found as Mortune in 1086, this is 'the marshland *tun* or farmstead', with the addition telling us it was held by William de Valence in 1252.

The minor name of Epney is derived from the Old English for 'Eoppa's island'

Chapter Thirteen

N

NAILSWORTH

The only early form of note comes from 1196 as Nailleswurd, a name which describes 'the enclosure of a man called Naegl' and which features a Saxon personal name followed by Old English *worth*.

Locally we find the name of Watledge, a name derived from Old English and referring to 'Wada's scarp'. Close to the Forest Green and also to be associated with the Ancient Order of Foresters, either could have given a name to the Jovial Foresters. The addition of 'Happy, Jolly, etc', is commonplace in pub names, suggesting they were happy to be here.

The river at Nailsworth

NAUNTON

A name which we would expect to find more often than it does. It is from Old English *niwe-tun* and describes 'the new farmstead'. This settlement near Winchcombe is recorded as Niewtone in Domesday.

Here is Aylworth, a name which tells us it was once 'Aegel's enclosure'; Harford is 'the river crossing where harts or stags are seen'; while Parker's Barn and Parker's Coppice remember the Parker family, who were represented by William, Samuel and Richard in the seventeenth century.

NEWENT

This name is similar to that of Naunton above and is recorded as Noent in Domesday. It also refers to 'the new place' and yet, ironically, is from the much earlier Celtic tongue and is at least 1,500 years old.

Welcoming names have long been associated with public houses, such is the case with the Travellers Rest. The Yew Tree Inn reflects the most obvious local landmark, easier to see from afar than the pub ever would be. The Black Dog most likely refers to the Labrador, which was first known in the south and west of England. However earlier pubs would be named after Guy Beauchamp, Earl of Warwick who was known as the Black Dog of Arden. Interestingly the phrase was also used in the nieteenth century to describe someone or some period when, for any number of reasons, moods were at a low ebb; in the preceding century 'black dog' was also used to describe a counterfeit shilling.

Within this parish we find Botloe's Green, which refers to 'Bota's mound'; Cugley was once 'Cugga's woodland clearing'; 'Cylla's cottage' is today known as Kilcot; Great Boulsdon is 'the larger pasture for bullocks'; Okle Clifford is the *ac-leah* or 'woodland clearing by the ash trees' which was associated with Walter de Clifford in 1221; Ploddy House is from *plodde* meaning the '(place at) the pool or puddle'; Stardens tells us of 'the valley below the projecting tongue of land'; and while Layne's Farm may seem to be a personal name, it actually comes from Old English *leyne* meaning 'arable strip of land'.

NEWINGTON BAGPATH

With records of Neueton in 1086 and as Newintone Baggepathe in 1327, the basic name is predictably 'the new *tun* or farmstead'. This is a fairly common name and takes its addition from Old English *bagga-penn* which describes 'the bag-shaped *penn* or fold'.

The name of Calcote Farm is not very inviting, for it refers to the 'cold or exposed cottages'.

NEWLAND

It is tempting to suggest that this is simply 'the new area of land', and yet this does seem overly simplistic, even when discussing place names. Logically the 'new land'

would have been used for something and yet, without further documented evidence, it is impossible to suggest what specific purpose that may have been — although it is safe to assume it would have been only for agricultural or building purposes.

Minor names in this parish include Chelfridge or 'the ridge where calves are reared', with Noxon another livestock reference as 'the wether sheep farm', a wether being a castrated ram, the ovine equivalent of a bovine heifer.

NEWNHAM

The only early record of note for this place name is as Nevneham in Domesday. However this is a fairly common name and derived from Old English *niwe-ham* and describing 'the new homestead'.

Local names include Ruddle or 'the woodland clearing where reeds are abundant', and Stears from Old English *staefer* and describing 'the post or stake' which would have acted as a marker.

NIBLEY

A name recorded in 1189 as Nubbelee and which comes from Old English *hnybba-leah*. This is 'the woodland clearing near the peak', although it should be realised that the term 'peak' is not the pointed bleak mountain-top but simply a Saxon word for 'summit'.

NOLEHAM BROOK

Joining the Avon at Welford-on-Avon, the brook is recorded as Riuulum de Nolland in 1540 and Nollande in 1575. There are two potential origins for this name, either Old English *knoll-hamm* and referring to 'the water meadow near the dome-shaped hill', or some other place name long lost.

NORTH CERNEY

Minor names here include Calmsden, from 'Calmund's valley'; Woodmancote is 'the cottage or shed of the woodman'; and Scrubditch which is a reference to 'the earthwork covered in brushwood'.

NORTHLEACH

As discussed under the name of Leach and Eastleach, this is an Old English name for the 'stream flowing through boggy land'. Here the place is 'the northern estate on the River Leach' and is recorded as Lecce in 1086 and Northlecche in 1200.

The Wheatsheaf Inn is a common name and features a symbol featured in several coats of arms, most notably those of the Worshipful Company of Bakers and the Brewers' Company.

A milestone at North Nibley

NORTH NIBLEY

Recorded as Hnibbanlege in 940, this name is north of that of Nibley.

Sharcliffe comes from *scearn-clif* or 'the filthy or muddy slope'; Bowcote Wood tells us the wood was named after 'the log hut' here; Innocks comes from inhoke, describing 'land temporarily enclosed for cultivation'; Bassett Court was home to Sir Anselm Basset in 1284; Hunt's Court is also named after a local family; and the Isle of Rhe takes its name from Ile de Rhe near Rochelle in France, where men from Gloucestershire were stationed during the seventeenth century until removed by the notorious Cardinal Richelieu.

NORTHWICK

The name is found in a document of about 955 as Northwican, which comes from Old English *north-wic* and speaks of 'the northern dairy farm'.

NORTON

A name which, sormewhat predictably, means 'the north *tun* or farmstead'.

Minor names include the commonly found Bradley, which is always from 'the broad woodland clearing'. Wainlode Ford refers to the 'river crossing for wagons' where the

Severn is forded on the road to Hasefield Ham. The name has been transferred to nearby Wainlode Hill, hence why a hill has the stange name apparently meaning 'the wagon ford'.

NOTGROVE

Here the Old English *naet-graf* gave the name of 'the wet grove or copse', and is recorded as Nategraua in 1086 and Natangrafum in 716.

Local names include Shewhill Coppice or 'the hill of the scarecrow'; Stanborough Lane runs close by 'the stone barrow'; and Hulkground from *hulc* meaning 'shed'.

NYMPSFIELD

Whether it be Nymdesfelda in 862 or Nimdesdelde in 1086, this is clearly a place name meaning 'the open land by the holy place'. It is formed from two elements, Celtic *nimet* and Old English *feld*.

Kinley House was once a separate settlement as 'Cyna's woodland clearing'. The Rose and Crown is a patriotic pub name showing allegiance to the monarchy, in the case of the Crown, and to England represented by the rose.

Nympsfield Long Barow

Chapter Fourteen

O

OAKLE STREET

Found as simply Acle around 1270, this name comes from Old English *ac-leah* with the later addition of *straet* and describing 'the woodland clearing where oak trees grow on or by the Roman road'.

ODDINGTON

A name found as Otintone in 1066 and as Otindona in 1086, this name comes from a Saxon personal name and Old English *ing-tun* and refers to 'the farmstead associated with a man called Otta'.

OLD AVON RIVER

Recorded in 1539 as Olde Avon and le Olde Avon in 1545, it flows into the Severn at Tewkesbury. As the name indicates, this is the original course of the Warwickshire Avon before it joins the Severn at Upper Lode to the west of Tewkesbury. The alternative and more recent routes taken by this river are today known as the Avon and the Mill Avon, which join the Severn at the appropriately named Lower Lode to the southwest of the town.

OLDBURY ON THE HILL

This is a place name found several times in England, this example is recorded as Ealdanbyri in 972 and Aldeberie in 1086. The addition of 'on the Hill' does not appear before the eighteenth century and is self-explanatory. From Old English *eald-burh* this name means 'the old stronghold'.

OLDBURY UPON SEVERN

Recorded as Aldeburhe in 1185, this is another 'old stronghold', here the addition refers to the close proximity of the river, discussed under its own heading.

From Old English *cu-hyll* comes the name of Cowhill, which means exactly what it seems 'the hill where cows are grazed'. Pullen's Green was home to William and Ussell Pullen in 1618. Plython Lake comes from Old English *plega-thorn* or 'the thorn tree where sports games took place'. Finally Narlwood Rocks is a bank of rocks in the middle of the River Severn where the navigable channel is to the north. Hence the name means 'the north passage'.

OLDLAND

From Old English *ald-land* and recorded as Aldelande in 1086, this name may have put off any prospective buyers for it speaks of 'the old or long-used cultivated land'.

The Batch is a fairly common minor name describing 'the boggy area around a stream'. Cadbury Heath takes the name of the Cadbury family who were here in 1611. Grimsbury Lane features the element grim, which is used to refer to the pagan god Woden and also to a rather unpleasant creature such as a goblin. Hence this is either 'Woden's burh' or 'the burh of a goblin or spectre', with Old English *burh* a defensive bank and ditch around a settlement, although there are no signs of such today.

OLD SODBURY

A name found in 872 and 915 as Soppanbyrig and as Olde Sobbury in 1346, this name comes from a Saxon personal name with Old English *burh* and speaks of 'the fortified place of a man called Soppa'. The addition here is to distinguish it from Chipping Sodbury, and show it was the earlier of the two similarly named places.

Kingrove takes its name from 'Cena's woodland', while Cripplehole Wood features the Old English element *crypel* which means 'burrow', exactly the same as the second part of that name.

Old Sodbury

OLVESTON

From 955 as Aelvestune and in 1086 as Alvestone, this name tells us it was 'the farmstead of a man called Aelf' and features a Saxon personal name suffixed by Old English *tun*.

Awkley was 'Alca's woodland clearing'; Ostbridge takes its name from 'the bridge by the shoots (trailing water plants)'; and Tockington speaks of 'the farmstead associated with a man called Tocca'.

OVER

A name which seems as if there is something missing today, and yet it was recorded little differently in 1005 as Ofre. This comes from Old English *ofer* and telling us it was the '(place at) the ridge or slope'.

OWLPEN

The earliest surviving record is as Olepenne in 1189, a name which seems to describe 'Olla's pen or fold (for animals)'. Here is the unusual sounding name of Awkley, which comes from 'Alca's woodland clearing'.

OXENHALL

Recorded as Horsenehal in 1086 and as Oxenhale in 1221, this name comes from Old English referring to 'the nook of land where oxen are kept'. Note how the Domesday version mistakenly suggests the animals were horses, further evidence of the great survey being an unreliable source for place names owing to the differences in language.

Brandhill Wood comes from Old English *brand-hyll* meaning 'the burnt place on or by the hill'.

OXENTON

Domesday gives the name as Oxendone, itself from Old English *oxa-dun* and speaking of 'the hill where oxen are pastured'.

OZLEWORTH

Two possible origins for the place recorded as Osleuuorde in 1086 and as Oslan wyrth in 940. The most commonly quoted is a Saxon personal name and giving 'Osla's enclosure', however the alternative Old English *osle-worth* or 'the enclosure frequented by blackbirds' is surely preferable.

Chapter Fifteen

P

PAINSWICK

Domesday records the place as simply Wiche in 1086, later seen as Painswike in 1237. The original place name is from Old English *wic* or 'the dairy farm', to which the name of Pain Fitzjohn was added from the twelfth century as lord of the manor.

Locally we find an array of minor names and including Clissford Farm which takes its name from 'the nook of land of the steep bank'. Ebworth House was built on what was earlier 'Ebbi's enclosure'; Holcombe Farm stands in 'the hollow valley' and is from Old English *hol-cumb*; Kimsbury was 'Cynemaer's stronghold or fortification'; and Tocknells House tells us of 'Toca's nook of land'.

Catsbrain Tump features a name found only around this part of Gloucestershire and neighbouring Oxfordshire, it always refers to a rough clay soil with broken stones or grit and said to resemble the brain of the pet moggy. Cockshoot is from *cocc-sciete* and a common minor name in England, always referring to a 'glade where woodcock are netted'. The birds were highly prized as a delicacy for the tables of the rich, yet they were difficult to find even though they nest on the floor of woodland for their camouflage is well-nigh perfect and hunting dogs are of no assistance for they have no odour. But the birds can be frightened off and thus erecting nets at one end of the glade or 'shoot' would catch the birds flushed from their hiding place by beaters.

Jacks Green was home to the family named Jaques in 1567, Olivers was the abode of Thomas or Margaret Olyver in 1574, while a Saltbox is a dialect term describing a 'lean-to shed'. Finally Spoonbed Hill comes from Old English spon meaning 'chip, shaving' and therefore a place where Middle Age roofing shingles were produced. Here a bed or pile of chippings made in preparing or felling timber, would have provided a natural supply of wooden roof tiles, made be cleaving wood and probably stored here. In England they were usually of oak, although Scandinavians would have preferred the spruce which was much readily available in their homeland.

While the town is best known for the manicured yew trees in the churchyard, the pub is named after the oak — specifically the Royal Oak which hid Charles II on his flight from the Battle of Worcester. The yews undergo the annual 'clipping' ceremony on the closest Sunday to 19 September each year. Folklore maintains there are only ever 99 yews growing in the churchyard and, should another take root, the devil will emerge to yank it from the ground.

PARADISE

This is a place name found in several counties of England, although few if any are little more than a few fields. This is, as would be expected, the most picturesque and pleasant corner of the settlement. It comes from Middle English *paradis* and is recorded as Paradys in 1327.

PATCHWAY

Recorded as Petshaugh in 1276, this name comes from a Saxon personal name with Old English *haga* and describes 'the enclosure of a man called Peot'.

PAUNTLEY

Domesday records the name as Pantelie, which features the Welsh *pant* and Old English *leah* and telling us of 'the woodland clearing by or in a valley'.

Ketford is a name pointing to a river crossing known as 'Cydd', a ford'.

PEBWORTH

Listed as Pebewrthe in 848 and as Pebeworde in 1086, this is 'Peobba's enclosure'.

Minor names here include Broad Marston which predictably means 'the farmstead at the wide marsh'; and Ullington, or 'the farmstead associated with a man called Willa'.

PILNING

The earliest record traced is as Pyllyn in 1529, however this is thought to be a much earlier name and from Old English *pyll-ende* or 'the district by the stream'.

PINNOCK

A name derived from Old English *pennuc* meaning a 'small pen or fold' (for animals) and is recorded as Pignoscire in 1086 and as Pynnocke in 1327.

Minor names here include Farmcote, a corruption of *fearn-cot* and 'the cottage where ferns grow'; Beckbury Camp is the site of an ancient earthwork and the stream or beck associated with it; Hyde refers to a hide, a measurement of land which supports a family for a year, not a quantifiable area for it largely depends upon the productivity of the land and, of course, the size of the family.

PITCHCOMBE

Records of this name include Pychenecumbe in 1211 and as Pinchecomb in 1246, this has been suggested as being a reference to 'the pitch bearing minerals in the valley'.

However is this is true, then the supply was exhausted long ago and thus the more likely origin is as 'Pincen's valley'.

PLUMBERS BROOK

A small tributary of the Severn which joins the main course at Lydney. It was recorded in 1830 as Plumbers Brook, clearly from a family name which existed here before the nineteenth century.

POOLE

Old English *pol* can still be seen as meaning 'pool', with the later addition of the manorial name, this place was recorded as simply Pole in the tenth century.

POOLE KEYNES

Records of this name begin with Pole in the fourteenth century, a name which comes from Old English *pol* meaning '(place by) the pool'. To differentiate from the above name the addition, first seen in 1610 as Pole Canes, shows possession by Sir John Keynes who was certainly here by the fourteen century.

Minor names here include Flagham Brook, a minor tributary which comes from Old English *flagge-hamm* and refers to the 'reed or rush water meadow'.

PORTWAY

A common road name, but rarely is it seen as anything but a street or a short stretch of road between villages. This name tells us it was 'a road leading to an important town', thus the road to take to, and home from, market.

POULTON

A name which is particular interest to the author, for it forms part of his surname. Indeed it one of half a dozen places of this name ranging across England and all coming from Old English *pol-tun* or 'the farmstead by a pool'. The earliest record of this name is as Pultune in 855.

This was once a detached parish which was officially a part of Wiltshire, however today it is considered under the control of Gloucestershire.

Local names here include Hull Piece from *hulu* and meaning 'shed'; Varnhills Lane would have led to or past 'the hill overgrown with ferns'; while the name of Ready Token is named after an inn, itself telling customers that only real money was acceptable as payment. Viney comes from two Old English words *fin* or 'heap of wood' and *haeg* 'enclosure'.

The Falcon Inn reminds us that falconry was a royal sport for centuries; the image is used in the coat of arms of Queen Elizabeth I and of William Shakespeare.

PRESTBURY

From Old English *preost-burh* this is 'the manor of the priests' and recorded as Preosdabyrig in 900 and Presteberie in 1086. In later years the priests gave way to a farming community who required refreshment and were welcomed by the landlord of the Plough Inn simply by adopting that name.

Burbage Street takes its name from 'the freehold property in the borough'; Noverton was the farmstead on a bank'; while Lutsoms seems most likely to come from a surname, itself from Middle English *lustsum* meaning 'pleasant'.

PRESTON

Listed in the modern form as early as 1221 this is a commonplace name and is always from Old English *preost-tun* or 'the farmstead of the priests'.

Local names include Ermin Farm, which takes its name from Ermine Street, discussed under its own entry. Merrill Hill is a common name from *myrig-hyll* or 'the pleasant hill'. Forestall is a perfect representation of the origin *fore-stall* and referring to 'the place in front of the farm. Wanthill is derived from Middle English *wante*, which could either be the old word for a 'mole' or a reference to the surname derived from it.

PRINKNASH PARK

The only early form of note is as Prikenhassce in 1270, a record which points to this being 'Princa's ash tree'.

PUCKLECHURCH

Records of Pucelancyrcan in 950 and Pulcrecerce in 1086 show this to be 'the church of a man called Pucela', where the personal name is followed by Old English *cirice*.

Feltham Brook is named after the region here of the same name, a name meaning 'the enclosed region where hay is stored or cut'. Two water springs are named after saints, however this does not explain why St Aldam's Well and St Bridget's Well are both said to be the perfect cure for sore eyes.

PURTON

Listed as Piritone in 1297, this name comes from Old English *pirige-tun* or 'the farmstead where pears are grown'.

Chapter Sixteen

Q

QUEDGELEY

A name not found before 1140, when it is given as Quedesleya, a Saxon name speaking of 'the woodland clearing of a man called Cweod'.

Woolstrop was once a separate settlement as 'Wulfric's outlying settlement'. Nass Field features the Middle English *atten-aesc-feld*, the end of the first element being mistakenly retained as part of the second and referring to the '(place) at the ash tree open land'.

The Cotswold area is synonymous with the rearing of sheep for their wool. After shearing and spinning the wool was woven, the main factor in the economic strength of our lands in the Middle Ages and directly linked to the eventual spread of the British Empire, and hence the name of the Weavers Arms. The Worshipful Company of Weavers is the oldest unbroken recorded guild, dating back to the middle of the twelfth century.

QUENINGTON

Domesday lists this place as Quenintone, which seems to be from Old English *cwene-tun* or 'the farmstead of the women'. However it may also be from a Saxon personal name with Old English *ing-tun* and describing 'the farmstead associated with a woman called Cwen'.

Here is Sleight Barn, a dialect term *slait* which is itself from Old English *slaeget* and referring to 'sheep pasture'; and Cloud Hills from clud describing the 'rocky outcrop'.

Chapter Seventeen

R

RANDWICK

A name meaning 'the dwelling on the edge or border', it is from Old English *rend-wic* and recorded as Rendewiche in 1121.

The Vine Tree Inn takes advantage of simple imagery to communicate the idea of refreshment being available within. While wine might be considered a modern crop in Britain, the Romans were certainly growing their own vineyards here 2,000 years ago.

RANGEWORTHY

In 1167 this name appears as Rengeswurda. The name has been identified as having two potential origins, either 'the enclosure of a man called Hrencga' or the Old English *hrynge-worth* and 'the enclosure made of stakes'.

REDMARLEY DABITOT

In 963 this name is found as Reodemaereleagge, as Ridmerlege in 1086, and as Rudmarleye Dabetot in 1324. Here the name of the place is derived from Old English *hreod-mere* or 'the woodland clearing with a reedy pond' and is today suffixed by the lords of the manor from the time of Domesday, the d'Abitot family.

Carpenter's Farm was worked by John Carpenter in 1496, although it is unknown if he took part in the sports and contests which took place on the 'games clearing' now known as Playley Green.

REDWICK

From Old English *hreod-wic* and recorded as Hreodwican in 955 and Redeuuiche in 1086, this name tells us it was 'the dairy farm among the reeds'.

Chestle Pill describes 'the creek in the shingle'; and Stowick Farm is 'the stoney dairy farm'.

RENDCOMB

Domesday's Rindessumbe points to an origin of 'the valley of a stream called Hrinde', with the stream name meaning quite literally 'the pusher' and referring to its strength.

Other place names found here are Clifferdine Wood or 'the homestead near the ford by the bank'; Eycotfield tells us it was 'the cottage near the island of the open land'; Marsden Hill stood overlooking 'the boundary valley' which gave its name; and Iffcomb Wood grows in the 'ivy valley'.

RIDGEWAY

Whilst this is also used for the 105 mile long Cotswold Ridgeway, the vast majority of these names are simply a small section of a much longer road. This is a name seen for part of Fosse Way and Akeman Street. Furthermore the name always describes an ancient track which followed the higher ridge of land as much as possible, for the lower reaches were much harder to traverse.

RISSINGTON

Found in Domesday as Risendune and from Old English *hrisen-dun*, this place name refers to 'the hill where brushwood grows'.

Four minor names here tell not just the history of the place but of the people who have lived here: Hank's Coppice reminds us of Alice and John Hanke, here in 1568; Collier's Hill Barn took the name of John Collier, here in 1803; Forty Copse is named after William Forty of neighbouring Slaughter in 1806; and Cate Britain, a name virtually unchanged since it was home to Kates Britton in 1830.

ROCKHAMPTON

With only Domesday's record of Rochemtune as a guide, it is difficult to see if this is *rocc-tun* and 'the homestead by the rock' or *hroc-ham-tun* and 'the farmstead frequented by rooks'.

RODBOROUGH

Listed as Roddan beorg in 716 and as Radeberwe in 1287, this name comes from Old English *rodd-beorg* meaning 'the hill with the rod or stick', probably a marker point.

Minor names here include The Archers, named after former resident John Achard who was here in 1216. Cold Bath Field marks the position where a well was sunk centuries ago. No parish has a regular shape, indeed often there is a strip of land which stretches further away from the centre than any other. These farthest flung corners of the parish were often saddled with what is described as a 'remoteness' name, often taking the name of the most distant part of the then British Empire. This is how the name of Montserratt appeared here and also that of Little Britain, not quite so much remote

The Clothiers Arms
public house
at Rodborough

but likely coined by a rather overwhelmed ploughman who thought this a huge area to work and described it as 'like ploughing a Little Britain'.

The local is the Prince Albert (1819-61), named after the consort of Queen Victoria who greatly influenced the modern role and image of the monarchy. He certainly divorced the royal family from politics, however the idea that he alone was responsible for introducing the idea of Christmas trees to Britain does not stand up to historical evidence.

RODLEY

From Old English *hreod-leah* and recorded as Rodele in Domesday, this name means it was 'the clearing among the reeds'.

RODMARTON

Domesday sees this place as Redmertone, a name seen to come from Old English *hreod-mere-tun* and 'the farmstead by a reedy pool'.

Minor names of this parish include Hazelton Farm, which was sited on the place originally known as 'the farmstead of the hazel trees'; Hullasey House was built on 'Hunlaf's hide of land'; and Hocberry tells us it was 'the site of a long barrow and a Roman villa. Yet the most unusual name is that of Culkerton, where the common element *tun* or 'farmstead' is preceded by Old English *cyclan* meaning 'belch' and most likely used as a nickname, although how anyone earns such a name is not covered by the remit of this book.

ROEL

Recorded as Rawelle in 1050 and as Rowelle in 1233, this name comes from Old English *ra-wella* and describes the 'spring or stream frequented by roebuck'.

RUARDEAN

Listed as Rwirdin in 1086, this name could have one of two origins. This could be Old English *ryge-worthign* or Celtic *riu* with Old English *worthign*, although both have identical meaning of 'the rye hill or enclosure'.

RUDFORD

Listed as Rudeford in Domeday, this name comes from Old English *hreod-ford* and describes 'the ford among the reeds'.

Chapter Eighteen

S

ST BRIAVELS

A name not recorded until 1130 when it appeared as (the Castle of) Sanctus Briauel. This name came from the Welsh saint of this name and was named deliberately.

Big's Weir is a corruption of 'Biccel's weir', the Hudnalls an abbreviation of 'Hudda's nooks of land', and Wyegate Hill was a settlement at 'Wicga's gate'.

SAINTBURY

In 1086 Domesday shows this name as Svinberie, while by 1186 this name appears as Seinesberia. Here is an Old English place name from a personal name suffixed by *burh* and speaking of 'the fortified place of a man called Saewine'.

Wall Farm is located near ancient earthworks, while Gun Cottages was home to Jeffrey Gun in 1675.

ST GEORGE

The region of St George takes its name from the dedication of the parish church. Blackswarth comes from 'Blaecan's enclosure', while Crew's Hole is named after the Crew family who had come to the area by 1777.

SALPERTON

In 1086 this name is found as Salpretune and speaks of this being 'the farmstead on a salt way' from Old English *salt-here-paeth-tun*. If anyone could show that another salt route crossed this point near here, it may be suggested that this was a distribution point where the salt was dropped and traded for other goods. Sadly there is no surviving record today, save for the place name which is a good clue but requires confirmation.

The field name of Bann Furlong is suggested at being '220 yards in length where beans were grown'. However while the furlong is a standard 220 yards, the real length is described by the name as 'a far long' and is the greatest distance the plough team can

travel before needing a rest. Clearly this will differ greatly depending on the oxen, the plough and, most importantly, the soil.

SALTWAY

As Gloucestershire stands south of Worcestershire and much of the salt from Droitwich was transported south, it is no surprise to find this road name. However it may come as a surprise to find how many saltways survive to the twenty-first century, although many of these are simply short stretches of the original routes.

SANDHURST

Domesday lists this name as Sanher, while by the twelfth century this name appears in its modern form. This is from Old English *sand-hyrst* and referring to the 'sandy wooded hill'.

Abloads Court is a region taking its name from 'Abload's river crossing'; Willington Court began as 'the farmstead near the willows'; Mussel End is 'the valley in the marsh'; Wallsworth was 'the Welshman's enclosure'; Forty Green is nothing numerical but the surname of a former resident; and Brawn Farm from Old English *breow-aern* or 'the brew house'.

SAPPERTON

One of those place names which delights the author for it produces an image of life in Saxon times. Recorded as Sapertun in 1075 and Sapletone in Domesday, this name comes from Old English *sapere-tun* and meaning this was 'the farmstead of the soap makers or soap merchants'. This was not greatly different to that used today, although the ingredients were different. It was perfumed and would not have produced a great lather, yet the most obvious difference was the texture. This was no slippery bar of soap which is so difficult to hold on to when wet; this was a coarse, rough cake which would have been quite abrasive against the skin.

An old road gave its name to the Daneway Inn. While there are suggestions that it referred to land held by Danes, there is no evidence to support this idea and, in truth, it is probably a corruption of 'the down way'.

SAUL

While this place name has no connection whatsoever with the Biblical figure of this name, there can be little doubt the spelling has been affected by it. First found as Salle in the twelfth century, this name comes from Old English *salh-leah* and describes 'the woodland clearing where sallow trees grow'.

The Anchor Inn is an early pub name, most likely taken by landlords for it is easily recognised and may also have shown some connection to the sea. However in reality so many 'anchors' are far from the sea and it is more likely to be a Biblical reference,

found in the Book of Hebrews that one's faith will anchor a soul through life's inevitable storms.

SELSLEY

Sadly the earliest surviving record of this name comes from the eighteenth century, which is not only rather late but is identical to the modern form. Doubtless there were earlier records and, unless these are discovered, the origins and meaning are unknown.

The local is the Bell Inn, another reminder of the close association between the village pub and the parish church. What seems to be an odd link today, in the days when the vast majority of the population worked the land, these two buildings were probably the largest in the community and would have been where friends and relatives would meet.

SEVENHAMPTON

Recorded as Sevenhamtone in 1086, it would be easy to suggest this alludes to the largest river in this part of Britain. Yet the River Severn is not the origin of the first element but the number seven — sadly still the mis-spelling most often seen for the river name for those whose lives are unaffected by it. This name comes from Old English *seofen-ham-tun* and describes the 'village of seven homesteads'.

Minor names found here are Brockhampton or 'the homestead by a brook'; Annis Wood takes its name from a lady who went by the name of Anneis, a variant of Agnes; and Puckham Farm and Puckham Woods share an origin of *pucca-cumb* and refers to 'the goblin valley'.

SEVERN (RIVER)

Records of this major river go back a long way, indeed they are found as early as the second century AD as Sabrina, with later forms of Saberna in 706, Saeferne in 757, be Saefern in 910, Saverna in 1086, and Severne in 1248.

It is the longest river in Britain at 220 miles and drops 2,000 feet from its source in Plynlimon in Wales and has the greatest water flow of any river of the mainland. An important route into the heart of England and Wales since man repopulated Britain at the end of the last Ice Age it has, together with its many tributaries, been a natural boundary between England and Wales, if not an actual border. Navigable upstream as far as Welshpool, it is tidal as far as Gloucester Docks. The lower reaches of the Severn are the scene of a phenomenon known as the Severn Bore, a wave of up to seven feet in height and the product of a tidal range of 49 feet coupled with the funnelling effect of the Severn Estuary.

Such a large and important river has attracted a great deal of attention since mankind first saw its waters, not only from practical but also religious and ritual purposes. In its higher reaches the river is associated with Sabrina, as seen in the earliest record of the name, also known as Hafren and a deity or water spirit said to have drowned in the river. The Welsh name for the river, the Afon Hafren, is derived from this Celtic deity,

while the Latin version of this name is Sabrina. The same deity is seen in Ireland, where the old name of the River Lee through Cork was the Sabrann. Perhaps this is the basis for the name of the Severn. However this does not explain why the lower Severn, the tidal reaches below Gloucester, is where the river is associated with Noadu (Nodens to the Romans) who is depicted riding a seahorse and riding the crest of the Severn bore.

SEZINCOTE

To find an English place name with a 'z' is very unusual, indeed statistically it occurs far less regularly than would be expected. Furthermore the vast majority of these names which do contain the last letter of the alphabet are in the south-west of England, clearly a result of the pronunciation. This name is recorded as Chiesnecote in 1086, which comes from Old English *cisen-cot* and refers to the '(place at) the gravelly cottages'. Obviously the gravel does not refer to the cottages themselves but on the land on which they were constructed.

Locally we find Clapley, 'the woodland clearing of the hill'; Camp, predictably 'an ancient encampment'; Rye Farm refers to it being 'at the water meadow', the name from Middle English *atter-eye* and describing its position at the confluence of two streams quite perfectly.

SHARPNESS

Domesday's record of this name is simply as Nesse in 1086, while by 1368 this had become Schobbenasse. This name is undoubtedly from 'the headland of a man called Scobba', with the Saxon personal name followed by Old English *naess*.

SHERBORNE

A fairly common name, found with a number of slightly different spellings. Domesday shows this as Scireburne, which comes from Old English *scir-burna* and tells us this was the '(place at) the bright or clear stream'.

The local name of Laughcroft comes from either Old English *laefer* 'reed bed' or the Saxon personal name Leofhere.

SHIPTON

Shipton is a common name and always from *sceap-tun* or 'the sheep farmstead'. Minor names include Shipton Solers, which adds the name of former resident William Solers who was here in 1221. While Hampen comes from the Saxon 'Hagena's pen or fold'.

SHIPTON MOYNE

A place name found as Sciptone in 1086 and as Schipton Moine in 1287. The basic name here is derived from Old English *sceap-tun* of 'the sheep farmstead', while the

addition is manorial and refers to the Moygne family who were here from the twelfth century.

Locally we find names which also reflect the history of the settlement. Shipton Dovel is also 'the sheep farmstead', although here the lord of the manor was one William de Ou, although the surbame is somewhat corrupted. Foss Bridge carries the Fosse Way across the water below, while Wormwell Lane follows the line of 'snake hill' from Old English *wyrm-hyll*.

One of the most unusual pub names in the land is that of the Cat and Custard Pot, however its origins are even stranger. The name was coined by Robert Surtees who, in his novel *Handley Cross* published in 1843, used it as the meeting place for the hounds belonging to Mr John Jorrocks, the engaging if rather coarse Cockney grocer who was the principal character in his stories.

SHORNCOTE

Domesday's record of Shernecote is little difference to either the modern form or indeed to the original Old English *scearn-cot*. Thus it is easy to see this place as coming from 'the cottages in a dirty or muddy place'.

SHURDINGTON

In 1150 this name is listed as Surditona, where a Saxon personal name has the added elements of *ing-tun* and telling us this was 'the farmstead associated with a man called Scryda'.

Locally we find The Tynings, from Old English *tyning* or 'fence'; with Croppets coming from the Middle English surname Cropet.

Locals drink at the Cheese Rollers, a name derived from the sixteenth-century Whit Monday ritual of rolling (and chasing after) large cheeses down Cooper's Hill. Competitors gather at the summit with a round of Double Gloucester and, one second after it is released, attempt to catch it and cross the finishing line down a daunting incline which is quite as precipitous as it appears. Injuries are common for it is virtually impossible to stay on one's feet during the descent, the same is true for the spectators who are in real danger of being hit by an out-of-control competitor tumbling down the slope (or indeed the cheese). The cheese could never be caught for it reaches speeds of up to 70 miles per hour, passing the finishing line well before its pursuers. There are actually two races, one for men and one for women, the winner of each receiving a large cheese and a cash reward. Incidentally, during the years of the war and afterwards, when cheese was rationed, the race still went ahead — with a wooden 'cheese' replacing the Double Gloucester. The origins of the event, and even the date, is the subject of great speculation to which the only answer will probably always be that it is unknown.

SIDDINGTON

Domesday's record of Sudintone is little different from the eleventh-century record of the previous name and yet the meaning and origins are quite different. Here Old English

suth-in-tun speaks of 'that part of the settlement in the south of the township'.

Locally we find Worm's Farm a name which could be a surname or a nickname, or simply refer to 'snakes' which is what the Old English *wurm means*. Field names include Nigham which takes its name from 'the nearby meadow'; Old Lain's is from *leyne* or 'the later, the arable strip'; and Purley, an Early Modern English *purlieu*, meaning 'on the outskirts' of the parish.

SISTON

Domesday's listing of Sistone confirms our original suspicions that this is from Old English 'Sige's *tun* or farmstead'.

Nearby there was 'Waerma's woodland clearing', once a separate settlement but now Warmley is a part of this parish.

SLAUGHTER (LOWER & UPPER)

For tourists this is one of the most endearing of the names found in and around the region of the Cotswolds. The additions are clearly referring to their respective positions, while Old English *slohtre* tells us this was originally 'the muddy place'. The name is recorded as Sclostre in Domesday.

Field names at Lower Slaughter here include Angerman, named after a local family; Knave Castle, named after 'the earthwork frequented by youths'; and Sturt, from Old English *steort*, 'the tail of land' (referring to its shape). While at Upper Slaughter is the name of Long Fryday, a field name which is an example of the kind of things which amused our ancestors. This is named after Good Friday, traditionally a time of fasting and alluding to this unproductive land being only capable of feeding a family on such days.

SLIMBRIDGE

Today this name is synonymous with the bird sanctuary, a wetland for waterfowl and visited by thousands every year. However there was a settlement here well before Peter Scott decided this was the place to create this spectacle, which Domesday gives as Heslinbruge in 1086 and is listed as Slimbrugia in 1153. Undoubtedly this refers to 'the bridge over the causeway, or muddy place' and is from Old English *slim-brycg*.

The Warth describes itself as 'the marshy shore meadow' and is exactly how we would imagine the wildlife sanctuary. Catscastle is thought to refer to 'the house overrun by cats', however cats are not particularly gregarious animals and it seems more likely to be a personal name. Rolls Court is not after the prestigious car for it existed centuries before the existence of the internal combustion engine; the name refers to builder Thomas Rolles who was here in the sixteenth century.

The local here is the Tudor Arms, clearly a reference to the House of Tudor which reigned in England from 1485 to 1603. Ironically the name is of Welsh origin in Tewdwr, likely to have evolved from a Christian name akin to Theodore. Owain Tudor married Catherine, wife and queen of Henry V, and their grandson Henry VII eventually became king following the Battle of Bosworth Field on 22nd August 1485.

SNOWSHILL

The earliest record comes from Domesday as Snawesille, which refers to the Old English *snaw-hyll* and 'the hill where fallen snow lies for some time'. In effect this speaks of the hillside, a hollow near where Snowshill Manor lies today. Indeed it is because it is sheltered by these surrounding hills that the sun cannot warm the land as quickly, leaving the snow lying here for some time after the surrounding countryside was returned to its familiar green.

Hyatt's Pitt takes the name of the Hyall family, who were here from several generations; while the 'homestead by the brook' provided the inspiration for both Great Brockhampton and Little Brockhampton.

SOMERFORD KEYNES

Here is a fairly common place name, hence the manorial addition referring to the de Kaynes family who were here in the thirteenth century. This name is recorded as Sumerford in 685 and Somerford Keynes in 1291, with the first element coming from Old English or Saxon *sumor-ford* which has often been interpreted incorrectly in the past. This is not 'the summer ford' but 'the ford only crossable in the summer months', the difference is slight but very important. The wrong definition here suggests a pleasant and gentle place, whereas the correct explanation tells travellers to avoid attempting to cross the river at this point unless the weather had been mainly dry and to find an alternative route in the colder months.

Locally we find Shorncote or 'the cottage in a mucky place or near a dung hill'; Neigh Bridge is from Middle English *atten-ea-brycg* or the '(place at) the river bridge'; Somerford Hask seems to be from *hassuc* and thus 'the clump of coarse grass at the ford only used in summer'; and Pills Moor from Old English *pil* and meaning 'pile, shaft' and which likely points to a stake used as a marshland track mark.

The Bakers Arms reminds us that, for many years, the baker and the brewer in a small community were often the same person.

SOUTHAM

Recorded in 991 as Suth-ham this is exactly as the Old English *suth-ham* and tells us it was 'the southern homestead'.

Brockhampton tells us of the 'farmstead of the water meadow by the brook'; Wontley Farm began life as 'Anta's burial mound'; Nutterswood, despite what some locals would have us believe, has nothing to do with anyone particularly zany but refers to 'the wood of the nut gatherers'. On the top of Nottingham Hill is a large rectangular fortification which was known as 'Cocca's fortification' — later this name was taken by two modern place names, Stony Cockbury lies on stony land while Rushy Cockbury was near rushes'.

This region was once held by Elizabeth, the wife of Edward IV, hence the name of Queen's Wood. Locally we find Haymes, which takes the name of Richard Haym who was here in 1385; Huddlestone's Table remembers Sir John Hudleston in 1548; and Kayte Farm was home to the Keyte family in 1839. However the name which tells the

best history of this place is that of Bellrope Ground, land set aside to be rented, with the resulting funds providing revenue for the church bell ropes.

SOUTHROP

The earliest surviving record is from 1140 as Sudthropa, which comes from Old English *suth-throp* and refers to 'the southern outlying farmstead'. Whether this is telling us this place lay to the south of the main body of the settlement, or if it is saying it was the southernmost of two Old English *throps* is unclear.

Maps of this area show Stanford Hall, which takes its name from 'the stone ford'; Sparrow Copse, home to Edward Sparrow in 1771; Beastbrook, which tells us of this place being 'by the east of the brook'; and Tiltup which is sometimes said to be a corruption of 'hill top' but is more likely to represent the dialect term *tiltup* describing 'a covered wagon', itself an uncommon sight in Saxon England.

STANDISH

With the earliest record as Stanedis in 862, this name comes from Old English *stan-edisc* and refers to 'the stony enclosure'.

Minor names include Horsemarling Farm 'the clearing by the pool used by horses'; Oxlynch is 'the ridge where oxen are pastured'; Pidgemore Farm started life as Pydi's marshland'; and Putloe was an early settlement known as 'Putta's woodland clearing'. However there is one unfortunate corruption in Vinegar Hill, for the original name was that of vineyard.

STANLEY PONTLARGE

A name found as Stanlege in 1086 and as Standley Pountlarge in 1588. This is from Old English *stan-leah* and describes 'the stony woodland clearing'.

STANTON

A very common name found throughout England and usually with a second element for distinction. Listed as Stantone in Domesday, this name comes from Old English *stan-tun* and recalls this was 'the farmstead on stony ground'.

Shenbarrow Hill comes from Old English *scene-barrow* and describes 'the bright or beautiful hill'.

STANWAY

A name found in the twelfth century as Stanwege and from Old English *stan-weg* and describing this as the '(place at) the stony road'.

A map of this parish shows the names of Coscombe, which is either 'Costa's *cumb* or valley' or perhaps the first element here is Old English *cost* or 'excellent'. The name of

Taddington means 'the farmstead of a man called Tatherer'; while the name of Stumps Cross refers to the remaining stump of a stone cross at the top of Stanway Hill. The Leigh is a corruption, as shown by the record from 1779 as 'a small brook called the Leame', a river name which comes from *leme* and describes 'the artificial water course'. The name of Staite's Grove is undoubtedly a family name, however there are a number of candidates including Anne Stayte of Winchcomb in 1636, John Stayte of Gretton also in 1636, and Margaret Staite of Dumbleton in 1696.

STAPLETON

The name of this ancient parish is almost certainly from Old English *stapol-tun* or 'the farmstead with a stake or post', such used as a marker, possibly a meeting point for traders.

Two quite delightful minor names here which paint two very different pictures of the area. Boiling Well is not a literal description, however it seems to be derived from a documented record dated 1779 when the water is said to be bubbling from the spring as to be 'like a boiling caldron'. Yet no explanation is needed to understand why the overgrown and damp track was known as Snail Creep Lane.

STAUNTON

There is more than a passing similarity between this name and Stanton above, for it is thought to have exactly the same etymology and meaning of 'the farmstead on stony ground'. However it is possible the first element here could be a reference to a 'standing stone', though the records of Stantun in both the tenth and eleventh centuries do nothing to assist our investigations.

STAVERTON

The only early form we have to guide our search comes from 1086 and Domesday, where the name appears as Staruenton. This probably comes from Old English *staefer-tun* and describes 'the farmstead marked by staves'. This would also suggest that the place was not greatly overgrown, and the staves were necessary to show the boundaries. This would not have been undertaken lightly, for this was a major task.

STINCHCOMBE

A name first recorded around 1155 as Stintescombe, it is from Old English *stint-cumb* and tells us this was 'the valley frequented by the sandpiper or dunlin', and a name which enables the wildlife artist to draw a depiction of the place just by defining the place name.

Boisley Wood tells us of 'Bosa's woodland clearing'; Lorridge Bridge is a corruption of *hlaw-hlinc* or 'ridge with a tumulus'; and Barnsley Farm here speaks of 'Beornmod's woodland clearing'.

STOKE GIFFORD

A name recorded in 1086 as Stoche and in 1243 as Stokes Giffard. Old English *stoc* is probably the most common place name in England and almost always has a second distinguishing element. The meaning of *stoc* has long been argued and today is often said to be 'secondary settlement', however in the past the definition was given as 'special place'. In truth the latter is probably more accurate but has led to many people to envisage a shrine or heathen temple, where the real meaning of 'special' has been wildly exaggerated. It may well have been special simply because it was where a particular crop was grown, or it provided agricultural land where a surplus of grain was guaranteed, leading to a trading surplus and wealth. To those who lived here it would be special indeed, yet to others just another Saxon settlement.

The addition reminds us that the lords of this manor were the de Gifard family from the eleventh to the fourteenth centuries.

Stanley Farm features a common place name from Old English *stan-leah* referring to 'the stoney woodland clearing'.

STOKE ORCHARD

A name recorded as simply aet Stoce in 967 and as Stook in 1409. Old English *stoc* is a term used here as 'secondary settlement'. The addition has nothing to do with apples or apple trees, it is a corruption of Middle English *archere* or 'archer' and tells how archers in the service of the king were supplied with bows and arrows from this parish for forty days each year.

The name of Lowdilow Brake clearly describes this as 'the sheltered mound of or by the newly broken land for cultivation'.

STONE

Another quite common place name, recorded in Gloucestershire in 1204 and derived from Old English *stan*. It certainly refers to the 'place at the stone or stones' and yet surely there must have been a reason for this reference, however it does not seem to be the usual boundary marker so perhaps it was a meeting place or a signpost on a route.

Berkeley Pill refers to 'the tidal creek or inlet'; and the unusually named Apple Gobble features the Middle English element *jabble* which is used to mean 'to splash' or 'to shake up liquids' and likely refers to the production of cider.

STONEHOUSE

Listed in Domesday as Stanhus this name comes from Old English *stan-hus* and indeed does refer to 'the stone-built house'. This also enables us to infer that, at a time when most properties were constructed of wood, this must have been a very prosperous place indeed.

The Woolpack Inn is a reminder of the wealth and power of the British Empire, being ultimately traceable to when large areas of land were given over to the rearing of sheep. It was not the meat which provided the wealth but the wool. A woolpack was a large bale or stack of wool weighing 240 pounds.

STOW ON THE WOLD

A common place name which, as here, invariably has a second distinctive element. The basic name comes from Old English *stow* and here the meaning of 'the place of the assembly' is more likely to be 'the holy place' which comes from the same word.

Records of this name are found as Eduuardestou in 1086, Stoua in 1213, and Stowe on the Olde in 1574 — three forms where the thirteenth century is simply the basic name, the earlier Domesday shows it was 'St Edward's holy place', and by the sixteenth century 'the high ground cleared of forest'.

Locally we find Bayliffs Plat, a name derived from 'the small plot belonging to the bailiff'. Two pub names of note here, the Talbot is always ultimately a hunting reference, the white dog with white spots used on the hunt and the forerunner of the modern foxhound and staghound. The influential Talbot family used the image in their coat of arms.

The name of the Eagle and Child public house seems to be an odd name for a pub and has even more unusual origins for this is a heraldic reference. This image refers to the Earls of Derby, the Stanley family, who derived the image from an ancestor in the shape of Sir Thomas Latham. During the fourteenth century Latham, as was the norm for the time, fathered an illegitimate son whom he had placed beneath the tree where an eagle was nesting. On a walk with his wife the child was 'discovered' and he convinced her that the son should be adopted and raised by them as their own. For reasons unknown the majority of his wealth was inherited by his daughter Isobel, who married Sir John Stanley, and hence the image was incorporated by the Stanley family.

STOWELL

Found in Domesday as Stanuuelle and in 1287 as Stonewell, this name comes from Old English *stan-wella* and refers to the 'stoney spring or stream'.

The field name of Latter Math Meadow tells us it was 'the last mown meadow'.

STOUR (RIVER)

The Stour rises in Gloucestershire and flows north into Warwickshire to join the Warwickshire Avon at Clifford Chambers, whereupon it mixes with the waters of the parent river and heads back into Gloucestershire once more. Rivers know no administrative boundaries, only those of rock.

Records of this name begin in 704 as Sture, in 757 as Stures stream, in 1247 as Stura, and in 1577 as Stoure, all of which are thought to represent an unknown Celtic element. However sometimes perhaps it is just too easy to suggest these names are derived from an ancient and unwritten langauge and it is worthwhile looking elsewhere. While Latin can be set aside for the moment, for the Roman influence on place names is negligble, Germanic tongues are an obvious source for the Anglo-Saxons who came to our shores following the departure of the Empire in the fifth century AD not only brought the basis for our modern language but also gave names to more places in England than any other tongue.

River names are invariably descriptive, irrespective of the language of origin. Thus taking both criteria and looking for a word which may fit the bill we arrive at the

Germanic root of *stur* which is used to mean 'fierce, moody'. Of course it is not easy to see possible root words from languages of two thousand plus years ago, especially as this is a single syllable and could probably be found in many languages, albeit not always as a potential river name.

STROUD

One of Gloucestershire's most endearing towns, situated in a picturesque valley. The name is seen as La Strode in 1200, which can be seen as from Old English *strod* and meaning 'the marshy land overgrown with brushwood'.

Stroud Water is a small tributary of the Frome which joins the bigger river here. It is clearly derived from the name of the place, a process known as back-formation. Yet records of this as a river name only go back to Strodewater in 1475 and Strowdwater in 1547, and with records of the town name not that much older, it is certain that there was an earlier name for the river and probably the town too, although there is no suggestion they were the same.

Locally we find names such as Paganhill, not a heathen place of worship (at least not named for such) but a reference to 'Paga's hill'. Callowell was 'the well in bare land'; and Griffin's Mill was the home and workplace of Thomas Griffin in 1779.

The streets around Stroud have their own stories to tell. George Street is named from the George Hotel, itself symbolising one of the four Hanoverian kings of this name. Similarly King Street takes its name from the Kings Arms, later the Royal George Hotel,

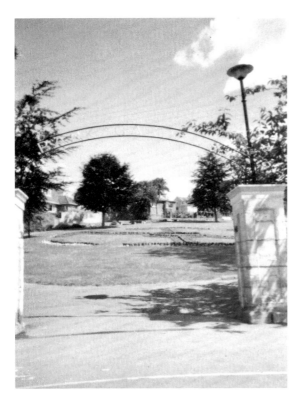

The entrance to the Stroud Park Gardens

Swan Lane from the Swan Inn and a heraldic reference to a landowner, and Bedford Street from the Bedford Arms Inn.

Union Street was where the meetings of the Guardians of Stroud Poor Law Union took place. Kendrick Lane and Kendrick Street were cut on land owned by Charles Freebury Kendrick. Threadneedle Street is a name associated with banking, the Bank of England is known as the 'Old Lady of Threadneedle Street', yet the Stroud street takes its name from the large factory built here in 1855 by Holloway Brothers, manufacturing the newly invented sewing machine. John Street and Russell Street are named after Lord John, 1st Earl Russell who served two terms as prime minister and the person to whom Charles Dickens dedicated his novel *A Tale of Two Cities*. Finally Havelock Terrace, which commemorates Major-General Sir Henry Havelock KCB, who is best known for his part in the Siege of Lucknow of 1857, an engagement which was to cost him his life. He died on Christmas Eve that year, officially due to 'tiredness and exhaustion', and a statue was erected in Trafalgar Square in his honour.

Public houses include the Crown & Sceptre Inn, which features two references to the monarchy. The Golden Fleece and the Clothiers Arms show how the wool trade was vital to the wealth of the Cotswolds area and which funded the wealth of the nation to explore and claim great stretches of the globe. These new territories were defended by the Royal Navy, symbolised by the oak trees of which the vessels were built and the basis for the British Oak Inn. The Cross Hands began life as a pub name by conveying a message of friendship and welcome, although signwriters have been somewhat imaginative in depicting same.

SUD BROOK

A name which has changed little since the earliest surviving record of Sudbrok in 1250. Indeed it has changed little since Saxon times when it would have been described as *sud-broc* or 'the southern stream'.

SUDELEY

Found as Sudlege in 1086 and as Suteleia in 1166, this is 'the southern woodland clearing', referring to its location in comparison to Winchcombe.

Minor names here include Beesmoor Plant, which is a corruption of 'Babbel's moorland'; Humblebee How, nothing to do with the insect but from Old English *hamol-loh* and describing 'the scarred hill'; Wadfield is from *wad-feld*, 'the open land where woad grows'; and Sponley Farm is from *spon-leah* or 'the woodland clearing where wood chippings were made or left' and revealing where long term cutting and shaping of wood took place.

SWELL (UPPER & LOWER)

The additions here are self-explanatory and perfectly named. The name is recorded as early as 706 as Swelle and as Svelle in Domesday in the eleventh century. Here the Old English *swelle* describes this as 'the rising ground or hill'.

Bowl Farm comes from Old English *botl* and describes 'the mansion, dwelling'; while Abbotswood was held by the abbot of Hailes Abbey from the thirteenth century.

SWILGATE

An unusual name for a river which joins the Severn at Tewkesbury and one which has a fairly uncommon origin. Most river names are derived from a description of the river and its surroundings, this river name has evidence of being influenced by man.

Listed as Aqua de Swillgate in 1540, this name undoubtedly existed much earlier than this for it comes from the Old English or Saxon languages of up to a thousand years before this time. The first element here is either *swille* which is literally 'wet and muddy mess' or more likely *swillan* meaning 'to wash, rinse'. Today the river description is better suited to the former *swille*, yet the second element of *geat* or 'gate' would suggest a floodgate or trap and such would require a much better flow of water and this is certainly probable in Saxon times.

Thus what at first appears to be a description of a muddy and overgrown backwater, was once a good flowing river which provided power for a mill and/or a trap for fish.

SWILL BROOK

A name obviously comparable to the previous name, yet early forms are unavailable and the earliest is from 1779 as Swillbrook. The brook joins the Thames at Ashton Keynes and, if it is also Old English *swillan*, may be used in a different sense of 'rinse, wash' and be where clothes were washed rather than a description of the scouring flow of the stream bed for the topography here simply would not produce that effect.

SWINDON

Coming from Old English *swin-dun*, this is a common place name and there are examples of varying sizes in many counties. The name is recorded as Svindone in Domesday and refers to the 'hill where pigs were kept'.

Bedwell Close takes its name from Old English *byden-wella* or 'the spring with a vessel or tub'. Runnings comes from Middle English *running* simply meaning 'pasturage'.

SYDE

Recorded in Domesday as Side, this is from Old English *side* and while the official definition is 'the long hill slope', it is easier to see as 'the side of the hill'.

Look at a map of Syde and you will find the unusual field name of Severals, which tells us this was where there were 'plots of privately owned land'.

Chapter Nineteen

T

TARLTON

Found as Torentune in 1086 and Torleton in 1204, this name comes from Old English *thorn-leah-tun* and speaks of 'the farmstead in the woodland clearing of thorn trees'.

TAYNTON

The only early form of note is a Tetinon in 1086. This Domesday record show a Saxon personal name followed by Old English *ing-tun* and describing 'the farmstead associated with a man called Taeta'.

In this parish is the name of Cravenhill, which tells us it was simply 'the hill with a ditch' and quite literally 'carved hill'.

TEDDINGTON

From Teottingtun in 780 and Teotintune in 1086, this name is similar to the previous entry and describes 'the estate associated with a man called Teotta' and also features the Old English elements *ing-tun* following a Saxon personal name.

Locally we find the region of Bengrove and that of Bangrove Farm. Both have identical origins in Old English *begen-graf* and describing 'the grove producing berries'.

The founder of the arboretum at Westonbirt was Robert Holford, a Nottingham squire. The area dedicated to the study and display of trees was not called an arboretum until 1838 when it was first included in the *Oxford English Dictionary*. Holford's efforts are marked by the naming of the Holford Arms public house here.

TEMPLE GUITING

The name here is a stream name, from Old English *gyte* and referring to the 'flood or torrent'. The name is recorded as Guttinges Templar in 1221, a clear reference to the Knights Templar who held this place in the thirteenth century.

The overly simplistic name of Ford marks the point where the Windrush is crossed by the road between Tewkesbury and Stow on the Wold. The 'barley farmstead' or Barton is a common minor place name, as is Kineton or 'the royal manor'.

TETBURY

A name recorded around 900 as Tettanbyrg and as Teteberie in 1086. This place name refers to 'the fortified place of a woman called Tette', where the female Saxon name is suffixed by Old English *burh*.

At Tetbury the Chipping Lane led to or past 'the market place' which gave it a name; while The Knapp comes from *cnaepp* meaning 'hill' and was formerly recorded as Cuckolds Nap and a reference to a resident who was known to have an unfaithful wife.

Magdalene Road is a pointer to the dedication of the local church to St Mary Magdalene. Alexander Gardens remembers Thomas Alexander, who died in 1806; Hodges Close reminds us of Elizabeth Hodges who died in 1723 and who bequeathed charitable funding for schools; and Romney Road, after Sir William Romney, the founder of the grammar school.

Here the local is known as the Trouble House Inn, an unusual but understandable name considering its history. The sign gives clues as to the history of the place, it features

Above left: The Trouble House at Tetbury
Above right: Stables in Tetbury

a Cavalier and a Roundhead armed and facing one another and showing how the place was here during the English Civil War. Behind these are two more gruesome images, one the hand of a man sticking out of the water and showing how a former landlord was found drowned in the local pond, although the circumstances surrounding his death have remained a mystery. The final image is a silhouette, the outline of a man hanging by the neck from a rope and showing how another old landlord had taken his own life after running into severe financial troubles.

Gumstool Hill and the public house there, also known as the Gumstool, are named from the 'cucking stool' which may well have once been here. This is a piece of equipment well-nigh identical to the better known ducking stool, but here the woman would have been raised on high (and where better than on a hill) and humiliated for her crimes — such as prostitution, bearing an illegitimate child, or common scold (being too loud and opinionated).

TETBURY UPTON

A name recorded in 1418 as Uptone juxta Tettbury, a name meaning 'the upper farmstead of Tetbury' and which has the addition to distinguish it from the previous name.

Minor names here include Charlton House or 'the farmstead of the peasants or freemen'; Doughton began life as 'the farmstead where ducks are seen'; Elmestree derives its name from 'the tree of a man called Aethelmund'; Wor Well's name tells us the Saxons were certainly aware it was 'the source of the Avon' for this is what the name means; Burgage is a Middle English word referring to 'the freehold property of this borough'; while Magdalene mead well may be either from *maegth-wella* meaning 'maiden spring' or *maegthe-wella* and thus 'the may weed spring'.

TEWKESBURY

Domesday records this name as Teodekesberie, a name which speaks of 'the fortified place of a man called Teodec' and features the Old English suffix *burh* following a personal name.

Minor names here reflect the amount of water in and around the town. Lower Lode and Upper Lode have a common origin in 'the passage over the river' and referring to a ferry — one, across the Severn just below the Mill Avon, has been obliterated by later works, the higher crossing point does retain evidence of locks. The Mythe is a word meaning 'river confluence'; Mythe Hook is a second name derived from this but actually refers to the 'pointed spit of land' between the two rivers. The Gouts features the dialect word *gout* referring to a 'mill stream or ditch'; while King John's Bridge was ordered by King John in 1205 when two oaks at Bushley were cut to help with construction either in the timber used for the bridge or the scaffolding for the stone.

Tolsey Lane takes its name from tolley and is a reference to a 'toll booth'. Gupshill began life as 'Guppi's hill'; Southwick tells us it was 'the southern dairy farm'; Perry Hill is 'pear tree hill' but is also known as Longdon Hill or 'the long hill'. Bank Alley takes its name from the bank which once adjoined the properties here and was left to the town in the will of the owner, Bartholomew Read. What was one lot in his lifetime was to be rebuilt into three properties and was originally known as Mr Read's Alley in his honour.

Above left: Tewkesbury Abbey

Above right: The Little Museum at Tewkesbury

Left: Tewkesbury Wier and Mill

St Mary's Lane, which took the name of the dedication of the church here, was in the news in the 1840s and not for good reasons. The Victorian era saw great strides in the recognition of health problems, although their solutions were rarely little more than temporary relief. However it did lead to the inhabitants being banned from keeping pigs in their homes, a common practice for many centuries and still present in the homes here. This was not the problem at the home of Jack the rag-and-bone man, no room for pigs here, not with his donkey in residence in the kitchen!

Pubs in Tewkesbury take their names from all of the usual areas. Heraldic imagery is seen in the names of the White Bear and Ye Olde Black Bear; religious links with the Cross Keys, Anchor, Yew Tree Inn, Bell Hotel, and Canterbury which is home to the Church of England; patriotic names include the Britannia, Albion Inn, King Johns Tavern, Kings Head Inn, Crown Inn, Queens Head Inn, and Royal Hop Pole which also has a brewing reference for good measure. The Nottingham Arms was the place of birth of a former landlord or proprietor; Berkeley Arms reminds us of just how much land was held by and influenced by that family; the Odessa was named to mark the time when the Black Sea port was being bombarded by the combined British and French fleets in 1854 during the Crimean War. The Gupshill Manor was once the manor house and is now an inn, the sign depicts an armoured knight on his steed and a reference to the Battle of Tewkesbury in 1471.

THAMES (RIVER)

The earliest record of this name dates from 51 BC as Tamesis, this name certainly is an ancient Celtic or pre-Celtic name which almost certainly refers to 'the dark one' although there are also those who suggest this is simply 'river'. If the former explanation is the real definition then it did not take its name from this part of its course in Gloucestershire where it is a bright and quite delightful river for the most part.

THORNBURY

A name recorded as Turneberie in 1086 and as Thornebiri in 1496. This comes from Old English *thorn-burh* or 'the fortified place overgrown by thorns'.

Street names here include Back Street, the 'alternative route', for there is no real 'back' to a town. Castle Street shows where there was once a fortification, while Gloucester Street heads off in the direction of the county town.

Locally we find Sibland or 'Sibba's piece of land'; Woolford's Mill must have been built after 'Wulf's ford'; Butt Lane is often thought to refer to the targets used in archery practice, when the vast majority refer to the 'strip of land at the edge of a ploughed field' where the plough turns and is thus left uncultivated; Milbury Heath takes its name from 'the fortified place near a mill'; Cassey Grove means 'the raised path' and is clearly related to the word 'causeway'; Clutterbuck Farm was named after the Cluterbrooke family who were here in 1589; Coppins Well took the name of Richard Coppin, who was here in 1615; and St Arild's Farm took its name from St Arild's Well, St Arild was martyred at Thornbury.

THRUPP

An Old English element which is found as a suffix and, as here, as the whole name. This name comes from Old English *throp* and speaks of 'the outlying farmstead'. Clearly such places lay outside another settlement and were probably an offshoot of that earlier place, however it is difficult to see which place would have been the original here for we would need to know what was around here when the place first appeared. Records of this place name start with Trop in 1261, however the place was certainly here well before that.

Locally is the name of Brimscombe, today known mainly for its mill but in the past 'Breme's valley'. This may have started off as a Christian name but was more commonly used as a nickname for it refers to one who was 'famous or fierce'.

TIBBERTON

Recorded as Tebriston in 1086, this Domesday record helps us define this name as 'Tidbeorht's *tun* or farmstead'.

TIDENHAM

Found as Dyddanhamme in 956 and Tedeneham in 1086, this features a Saxon personal name followed by Old English *hamm* and describing 'the enclosed place of a man called Dydda'.

Beachley takes it's name from 'Betti's leah or woodland clearing', while Buttington Tump is probably 'the farmstead associated with a man called Butta' but the root *butt* could also be used to mean 'tree stumps'.

TILNOTH (RIVER)

This may officially be a lost river name, but it was used within living memory for the upper reaches of the Coln. Recorded as Tillath in 736 and Tillnoth in 774, this is a very un-river like name and can only be from an Old English personal name which was probably used as a nickname and meaning 'the useful one'.

TIRLE BROOK

Despite the clear similarities with the following name, the two are of quite different origins. Here the name is recorded as Turlebroke in 1490, yet it is the earlier record from 760 as Tyrl which is of particular interest. This is exactly as the Old English *tyrl*, a name referring to the river as 'that which turns or rolls along a stream' and can be seen to be related to modern 'turmoil'. This river runs into the Swilgate near Tewkesbury.

TIRLEY

Just one early record of note for this name, that of Domesday's Trineleie. This represents Old English *trind-leah* and describing 'the circular woodland clearing'.

The Hawbridge Inn stands near the bridge of that name which crosses the Severn. From 'Cumbra's enclosure' comes the name of Cumberwood.

TOCKINGTON

Domesday's Tochintune tells us this was 'the estate associated with a man called Toca', a place name derived from a Saxon personal name followed by Old English *ing-tun*.

TODDINGTON

A name found elsewhere in England, but most are tiny places existing only as names on a map. Here the name is found as Todintun in 1086 and has the same basic formula as the previous place although here it is 'the farmstead associated with a man called Tuda'.

Locally we find Raymeadow, from *rye maed* and describing 'the meadow where rye grass grows'; the Varndells comes from Middle English *farendel*, itself from *feortha dael* and describing 'the feather dale' and when 'feather' is used in a place name it always refers to somewhere almost permanently wet; and the name of New Town, a *tun* or farmstead which has not been 'new' since at least 1327 when it was recorded as niwe tun.

The Pheasant Inn takes the name of a bird which is not only colourful but makes good eating.

Toddington Church

TODENHAM

A Saxon personal name followed by Old English *hamm* and referring to 'the enclosed valley of a man called Teoda', which is recorded as Todanhom in 804 and Teodeham in 1086.

Local place name reflect those who have lived in Todenham over the centuries: Cooper's Coppice was home to George Cooper in 1787, Phillip's Farm the abode of Henry Philips in 1741 and Grace Philips in 1784, and Timm's Coppice named after the family of Richard or Francis Tims in 1728.

TORMARTON

Domesday records this name as Tormentone, while 80 years later in 1166 the name has evolved to the modern form. It is difficult to see if this is *thorn-maere* and 'the boundary farmstead where thorn trees grow' or *thorn-mere-tun* and 'the farmstead by the pool where thorn trees grow'. Locally we find Brookman's Quarry, a reference to Thomas Brookman who was here in 1781.

TORTWORTH

Recorded as Torteword in Domesday, this name comes from Old English *worth* with a Saxon personal name and speaks of 'Torhta's enclosure'.

Crockley's Farm takes its name from Old English *crocc*, meaning 'crock pot' and referring either to where finished pottery was found or to evidence of pottery being made. The name of Tafernbach features two modern Welsh words describing the 'little tavern'.

TRYM (RIVER)

This is an Old English river name describing its flow and meaning 'the strong one'. The name comes from Old English *trum* and is recorded as Trin in 1712 and Trim in 1779.

TUFFLEY

Domesday shows this name is Tuffelege and describing this as 'Tuffa's woodland clearing' and featuring a Saxon name with Old English *leah*.

The Pike and Musket is a pub name featuring two weapons of times gone by, the pikestaff and the musket. An even earlier fighting man is seen in the name of the Gladiator Inn. The Fox and Elm may well have originally been the Fox, the addition giving a distinguishing addition to what would otherwise be two common pub names.

TURKDEAN

Found as Turcandene in 716, and as Turchedene in 1086, this is a place name meaning 'the valley of a river called Turce'. Here Old English *denu* follows a lost Celtic river

name which is thought to describe 'the place of boar'.

One field name tells us of one period in its history, for the name of Picked Close informs us it was 'picked bare' and had been cleared of all vegetation.

TWIGWORTH

Old English *worth* follows a Saxon personal name and describes this place as 'Twicga's enclosure' and recorded as Tuiggewrthe in 1216. However there is a chance the first element is *twigge* and thus describing 'the enclosure made with twigs'. While this latter name seems a barely credible description, it should be realised that what the Saxons would describe as a twig was any length of a tree which could not be utilised for building or otherwise worked.

A name like the Dye House would seem to suggest making of cloth, yet it is actually a corruption of 'the dairy house'.

TWYNING

Records of this name include Bituinaeum and Tveninge in 814 and 1086 respectively. This original place name comes from Old English *betweonan-eam* which can still be recognised as '(the place) between the rivers'; while the later record has the addition of *ingas*, and can only be defined as 'the settlement of the people in residence' which seems a quite ludicrous explanation today but must have been quite relevant at the time.

Local names include Stratford Bridge, a common name meaning 'the ford on the Roman road' and a reference to the ancient route from Worcester to Tewkesbury crossing the Ripple Brook and recorded as a salt way over many centuries. Shuthonger is a name meaning 'the wood on a steep slope'; Gubberhill takes its name from 'Gudbeorht's hill'; and Puckrup appears to come from Old English *puca-throp* or 'the farmstead haunted by goblins', although there is also a likelihood that this name came here via a personal or family name.

The Fleet public house takes the name of a local region referring to 'a tributary'.

TWYVER (RIVER)

A tributary of the Severn, joining it at Gloucester. Records are found as Wevere in 1351, Wyver in 1537, and Twyver River in 1830, a name which comes from Old English *wefer* meaning 'the winding stream'. The addition of the initial 'T' is from Middle English *atte wefer* literally 'at the Wefer' and a fairly common occurrence.

TYTHERINGTON

Domesday's record of Tidrentune does not provide many clues to the origin here, but without other early records is all we have to work from. Either this is Old English *ing-tun* following a personal name and explaining this as 'the estate associated with a man called Tydre'; or *tyddring-tun* which gives a much more interesting 'the farmstead where livestock are bred'.

Chapter Twenty

U

UCKINGTON

Found in Domesday as Hochinton this name describes the place as 'the farmstead associated with a man called Ucca', where the Saxon personal name precedes Old English *ing-tun*.

Bar Bridge is an area which takes its name from 'the bridge near a grove of trees'.

ULEY

The only early record of note is as Euuelege in 1086. This Domesday record, together with the modern form and a knowledge of the expected evolution of English place names, means this can be seen as coming from Old English *iw-leah*. This may not look much like the present form but the pronunciation is virtually identical and thus this is certainly 'the yew tree wood clearing'.

Bencombe is a name meaning 'Beonna's valley'; Wresden Farm comes from *wraest-dun* or 'the hill with a thicket'; Twyn is a modern Welsh word simply meaning 'hill'; and Hetty Pegler's Tump was associated with Edith Pegler in 1683.

The Old Crown Inn shows allegiance to the monarchy and the country.

UP HATHERLEY

The name here is from four Old English elements, *upp-hagu-thorn-leah*, and describing 'the up stream hawthorn woodland clearing'. Recorded as Athelai in 1086 and Hupheberleg in 1221, the prefix meaning 'higher upstream' is relative to Down Hatherley.

The Greatfield is an unusual name for a public house, but a field name of obvious meaning. Ansell Close was named Walter Ansell, named a freeman of the borough in 1960.

UPLANDS

This is a modern addition, a created name telling us exactly where it is to be found in the 'upper lands'.

Peghouse Farm is a minor name here which has been suggested as being a personal name, but is more likely to have been a sty or 'pig house'.

UPLEADON

Recorded as Ledene in 1086 and Upleden in 1253, this name refers to a settlement and its location 'higher up the River Leadon'. Here Old English *upp* prefixes the Old English river name meaning 'the broad stream'.

UPPER LYDBROOK

Even in the early thirteenth century this name was recorded as simply Luidebroc, a name which tells us it was the '(place on) the Hlyde Brook'. The is an Old English river name, meaning 'loud one', with the suffix *broc*. The addition, itself self-exlanatory, is to give the place distinction.

UPPER SOUDLEY

The earliest surviving record dates from 1221 as simply Suleie, from the Old English *suth-leah* and meaning 'the southern woodland clearing' with the obvious addition. Clearly the addition is in comparison to another Soudley or 'southern woodland clearing' and yet today there is none. Thus either the other place has been lost or has changed beyond all recognition.

UPTON CHEYNEY

Records of this name begin with Vppeton in 1190 and as Upton Chaune in 1325. Here the addition refers to the Cheyney family and is required because this is a very common place name, which is no surprise considering its origins are in Old English *upp-tun* or 'the higher farmstead'.

UPTON ST LEONARDS

As with the previous name this is 'the higher farmstead', here suffixed by the dedication of the local church to St Leonard. The name is recorded as Optune in 1086 and Upton Sancti Leonardi in 1287.

Idel Barrow tells us it was 'the empty barrow' and an ancient clue that the grave had already been robbed by the time the Saxons arrived here. Ockold End is 'the oak wood'; Pincott was 'Pinna's cottage'; Sneedham's Green refers to 'the homestead on the detached piece of land'; Bullens Manor Farm is a corruption of the surname Boleyn; and Commelines Mill reminds us that Commeline was rector of this parish from 1803 to 1812.

Chapter Twenty-One

V

VALE OF GLOUCESTER

Whilst this regional name may seem a modern creation, it has been around for at least eight centuries, found in 1125 as Vallis Gloecestrae and Valle de Gloccestria in 1316. It is not difficult to see this as being a reference to the Severn Valley as it flows near the city of Gloucester.

Chapter Twenty-Two

W

WAPLEY

A name meaning 'the woodland clearing by the spring', it is from Old English *wapol-leah* and recorded as Wapelei in 1086.

Codrington takes its name from the Old English for 'the farmstead associated with a man called Cutthere'.

WASHBOURNE (GREAT & LITTLE)

In 780 this name appears as Uassanburnan and in 1086 as Waseborne. This name comes from Old English *waesse-burna* and refers to 'the stream in alluvial land', with self-explanatory additions. This definition tells us more than it might at first seem, for the information can be extrapolated to show something of the place name.

As the name says, this was 'alluvial land', which tells us it was seasonally flooded by the stream and, as the river burst its banks and spread out across the land, slowed to deposit the minerals and silt (the alluvium) across the land. Far from being an inconvenience this was greatly welcomed, for it replenished the land and enabled crops to be grown every year without the land suffering from over-farming. Hence we can also deduce this was excellent farmland and would have produced great quantites of grain which could have been traded for other goods and made this a very prosperous community. Indeed this is probably the reason a second settlement grew not far from the first.

The name of Hob Nails is not only applied to a region but that of an old public house, indeed the name is probably derived from the licensed premises. These nails were those with large heads hammered into the soles of the boots of farm labourers, to reduce wear. This term was later used to refer to a clumsy or awkward individual, an alternative to being a clod hopper!

WELSH WAY

Seen several times in Gloucestershire, with its close proximity to Wales, this may be more likely to refer to the route taken by the Welsh into England (trading routes) than travelling in the opposite direction. However this does not always refer to the

principality, for the Old English reference was to a 'foreigner' and not specifically a Welshman.

WESTBURY ON SEVERN

The only early form of this name is as Wesberie in 1086. This undoubtedly comes from Old English *west-burh* and is 'the westerly stronghold'. The addition is an obvious reference to the large river which dominates the scene here and a name discussed under its own entry.

Redland is a corruption of 'the third part of a piece of land'; Durdham Down is related to the previous name in that it describes 'the hill belonging to Reland'; and Stoke Bishop is 'the dependent farmstead held by the Bishops of Worcester'. Adsett takes its name from 'Eadda's or Aeddi's dwelling or fold'; Chaxhill began life as 'Caec's hill'; Elton is a common name, here describing 'Aelfwine's farmstead'; and Rodley speaks of 'the woodland clearing where reeds grow'; Stantway was 'the stony road'.

Unla Water takes its name from Middle English *unlawe*, literally 'illegal' and referring to where an unlawful fishery was situated. However it may also be telling us more, for place names normally grow over a period of time, and there was never any official

The church at Westbury on Severn

naming as there is today. In this case it is quite possible that fish traps existed here for some time and, despite it being common knowledge, a blind eye was turned to this minor misdemeanour.

WESTCOTE

From Old English *west-cot* and recorded in the modern form as early as 1315. This name quite clearly refers to 'the westerly cottages'. One local name is very similar; the field name of Homestall refers to it being 'the site of the home'.

WEST DEAN

A name meaning 'the westerly valley' and west of other places featuring the Old English element *denu*.

Locally we find Blind Meed or 'the hidden or secluded waste woodland'; Moseley is 'the clearing in the marsh'; Gosty Knoll refers to 'the gorsey hill top'; and Purples Hill, not a reference to colour but a surname which was much more common in the seventeenth century than it is today.

WESTERLEIGH

Recorded as Westerlega in 1176, this name comes from Old English *westerra-leah* and describing 'the more westerly woodland clearing'. Of course this begs the question, more westerly than what and from what perspective? Answering this would be purely speculative and mainly depending upon when the name was first coined.

Henfield takes its name from 'the region of land frequented by hens (moorhens)', while Serridge House took the name of the region, itself from Old English *scir-hrycg* and describing 'the bright ridge'.

WEST LITTLETON

This 'small farmstead' has the addition to distinguish it from Littleton on Severn.

Here we find Butt's Lane which is said to be a reference to the unploughed strip at the edge of the field where the plough team turn. However, here the name does not appear until quite late and is probably a reference to Edmund Butt of Old Sodbury who married here in 1762.

WESTONBIRT

Listed as Westone in 1086, here is 'the western farmstead' in relation to Tetbury. The addition reminds us of the lord of the manor in 1242, one Richard le Bret.

One minor name here is that of Lasborough, which means 'the lesser barrow' and raises the question as to the location of the greater burial mound.

WESTON SUBEDGE

Found in Domesday as simply Westone which by 1255 had become Weston sub Egge. The basic name is from Old English and refers to 'the west farmstead', a common name which requires a second distinctive element, here found as describing its situation 'under the edge of the (Cotswolds) escarpment'.

Locally is Dover Hill, which was home to Robert Dover during the reign of James I. Dover initiated a number of games held annually during Whitsun week. The games ceased in 1852 but have been revived. The Cotswold Olimpick is held in a natural amphitheatre overlooking the Vale of Evesham and includes a five-mile race, falconry displays, Morris Dancing and dog displays. However the highlight for many occurs after darkness has fallen and the bonfire is lit by the Queen, fireworks ensue and a torchlit procession heads down the hill and dancing. Yet the best known featured 'sport' is that of Shin-Kicking, where competitors wearing white smocks and with straw stuffed down the front of their trousers to protect the shins, grasp the opponents shoulders and attempt to kick one another to the ground in a best of three contest.

There are three Nortons here named because they are in the 'north of the parish': Middle Norton has a self-explanatory addition, Norton Hall and Burnt Norton have a common origin for both remember 1741 when there was a major fire and the hall burned down and the owner, Sir John Keyt, lost his life. Eden's Folly was home to John Eden in 1747; White's Farm was where Richard White was living in 1685, and Poden Cottages comes from Middle English *pode-denu* or 'the toad valley'.

The church at Whaddon

WHADDON

The name is recorded in Domesday as Wadve, which shoes it comes from Old English *hwaete-dun* or 'the hill where wheat is grown'.

Close proximity to the Welsh border is evidenced by the name of Tan-y-ffordd, a name meaning 'below the road'; while Toots Farm refers to 'the look out place'.

WHEATENHURST

Recorded as Witenhert in the eleventh century, this name is either 'Hwita's wooded hill' or possibly 'the bright wooded hill'.

The field name of Egypt is a remoteness name, something given to the furthest corner of the parish.

WHETSTONES BROOK

Records of this name include Whetstonysbroke in 1492 and Wetstones Brook in 1830. This comes from Old English *hwet-stan-broc* and referring to 'the brook where whetstones are found'. The brook in question flows into the Severn at Newnham.

WHITESHILL

Here is a modern name, created around 1830 and seemingly for no etymological reason.

Locally we find Ruscombe, a place which tells us it was 'the valley of the rushes'. The Star is a common public house name, chosen for the simple image and also associated with the church, with the Woodcutters Arms a reference to those who worked in the extensive woodland around here.

WHITE WAY

A road which follows the ridgeway between Cirencester and almost as far as Compton Abdale. That it joins the Saltway serving Winchcomb and Stanway is significant, for this was probably another branch of the salt distribution network and hence the 'white way' refers to this vital commodity being traded along this route.

WHITTINGTON

With the earliest record as Wytinton in 1205, this name comes from a Saxon personal name and Old English *ing-tun* and describing 'the farmstead associated with Hwita'.

Minor names here describe 'the clearing near the wall' which is marked on maps as Whalley Farm; 'the homestead of the dairy farm' appears as Wycomb; and from *alor-wella* or 'the spring of or near the alder trees' comes the name of Arle Grove.

WICK

Even without the record of Wike in 1189, this could be seen as coming from Old English *wic* and referring to 'the specialised farm'. Invariably the speciality was dairy farming and is a common enough element usually found as a suffix.

Chesley Hill takes its name from Old English *ceastel* meaning 'heap of stones'. The name of Abson describes the 'abbot's manor'. Bridgeyate describes the 'bridge constructed by the gate of or to the newly broken land for cultivation'. There are documents claiming that three large stones were once here, stones used by the Druids in their religious rituals, and also evidence of a Roman villa.

WICKWAR

As with the previous name this is from Old English *wic* or 'the specialised farm' and probably a dairy farm. It is recorded as Wichen in 1086 and as Wykewarre in the thirteenth century. The addition, which would normally be expected to be the first element, follows because it is manorial and marks ownership by the la Warre family who were here from the early thirteenth century.

The local here was the New Inn, ironically the old name of what is now given as the Buthay Inn. Officially said to refer to the archery butts used by the local archers before the Battle of Crecy, this was probably due to the former lords of the manor of Wickwar La Warre family, who played a significant part in the engagement against the French. However, the true origin is more likely to be an old minor place name from Old English *but*, the strip of unploughed land at the edge where the plough team turn, and *haeg* 'an enclosed piece of land'.

WILLERSLEY

With records as Willerseye in 709 and Domesday's Willersei, this name features a Saxon personal name and the Old English *eg* and telling us this was 'island of a man called Wilhere or Wilheard'.

Condicup Farm is located on a sharp bend in the parish boundary, which has been suggested as being the reason Old French *contre-coup* or 'cut back'. Swire Hedge is another name which describes a feature in the landscape, this comes from Old English *sweora* and describes the 'neck of land'.

WINCHCOMBE

The earliest record known comes from the early ninth century as Wincelcumbe. This is from Old English *wincel-comb* and tells us it was 'the valley with a bend in it', indeed as it still is today.

Local names of note are plentiful. Street names include Vineyard Street, which ran alongside rather than to a vineyard which was here as early as 1327. Castle Street heads off in the direction of Sudeley Castle. Cole Street was where charcoal was burned or more likely sold.

Charingworth Court takes the name of the family represented by Henry de Charyngworth, who is listed as a juror in 1300, and Robert de Chaveryngworth, who owned a meadow in 1348; Coates comes from Old English for 'the cottages'; Corndean Hall comes from *cweorn-denu* or 'the valley with a mill'; Frampton began life as 'the famstead associated with a man called Freola'; and while Greet comes from *greote* or 'the gravelly place', Gretton tells us it was 'the farmstead near Greet'.

Langley Farm stands on the site of 'the long woodland clearing'; Littleworth was agricultural land 'of little value'; Naunton has not been 'the new farmstead' for many years; while Postlip takes its name from 'Pott's chasm or steep place'; and Stancombe Lane and Stancombe Wood share the common description of 'the stony place'.

People are also represented, as is the case with Cooper's Hill, home to Francis Cooper in 1684 and John Cooper in 1710; Dunn's Hill was the abode of Richard Dunne in 1610; from 1581 onwards Flukes Hill was home to the Flowke or Fluke family; and Parr's Farm is recorded as being the home of William Par in 1587 and Francis Parr in 1702. Finally we find Puck Pit Lane, a name which comes from Old English *puca-pytt* and describes 'the goblin haunted pit', sadly this particular snippet of folklore is long forgotten.

Local pubs include the Sun Inn, a welcoming image; the Old White Lion and the White Hart are both heraldic references; and the Plaisterers Arms is an obsolete form of 'plasterer', the sign showing the Worshipful Company of Plaisterers coat of arms.

WINDRUSH

This popular river, the epitome of a Cotswold stream, is recorded in Domesday as Wenric. This is thought to be a Celtic river name meaning 'the white fenland'. The name is found as Uuenrisc in 779, Wenrisc in 969, and Weberiche in 1247.

Locally we find Pinchpool Farm, home to William Pinchpool in 1316 and whose surname means 'the finch pool', however it will never be known if the man brought his name to the place or vice versa. Gospel Ground marks the spot where the gospel was read on the ancient ceremony of beating the bounds, blessing the parish in the hope of a bountiful crop.

WINSON

Domesday's Winestune shows this is a name from 'Wine's *tun* or farmstead'.

WINSTONE

As with the previous name the only record of this name comes from Domesday and yet despite the obvious similarities this is the only thing the two names have in common other than the county. In 1086 this is Winestan and tells us it was 'the boundary stone of a man called Wynna' and derived from a Saxon personal name with Old English *stan*.

Local names here include Salters Hill Barn, which stands on the road from Sapperton to Cheltenham, a known old saltway and further evidence of its existence. Greensward Dancers is a field name which would have been the venue for country dancing, although just how regularly this took place is unknown.

A Winstone roadsign

WINTERBOURNE

Found as Wintreborne in 1086, this name may seem it only flows in and around the coldest season. However the more logical explanation is that the stream flow was much stronger in the winter and probably made it impassable, thus the name is a warning and much the same as Somerford.

Frenchay is 'the copse of the Frome'; Sturden Court speaks of 'the hill near the stream called Stour'; and Pye Corner was home to Richard de la Pey in 1248.

WITHINGTON

Found as Wudiandun in 735 and Wididune in 1086, this name tells us it was 'the hill of a man called Widla' and is derived from a Saxon personal name and Old English *dun*.

Within this parish are names such as Little Colesbourne or 'the smaller cold stream'; Cassey Compton, 'the farmstead in the valley' which was held by the Cassey family by 1510; Cothill, 'the wet place of the cottages or huts'; Foxcote, 'the lair or den of the fox'; Fulford, 'the foul or dirty ford' which cross the stream here; Hales Wood, is 'the wood in the nook of land'; Hilcot tells us there was a 'cottage on a slope'; Mercombe Wood grows in 'the boundary valley'; 'Ald's spring or stream' is marked on the map as Owdeswell; and Badgerbury Plant is 'the place of the badger sett'.

The Mill Inn occupies the site of the old mill, the mill stream still runs through the picturesque grounds.

WOODCHESTER

Recorded as Uuduceastir in 716 and Widecestre in 1086, this name is derived from Old English *wudu-ceaster* and describes 'the Roman stronghold in the wood'.

Lagger Lane here takes the element *lagger* which is used specifically 'a narrow strip of unenclosed land uniting two parts of a farm'. Dingle Wood was 'the deep dell wood' and Pud Hill takes its name from Middle English *puddel* or 'pool' which would either have formed regularly on its slopes or at its base.

The number of public houses named from the wealth of the region based on wool production means several places sharing the same name. Here the name is the Ram Inn, the symbol appearing in the arms of the Worshipful Company of Clothworkers and not the a direct reference to the male sheep.

WOODMANCOTE

The earliest record of this name is almost identical to the modern form, as Wodemancote in the twelfth century. This is certainly from *wudu-mann-cot*, Old English for 'the cottages of the woodsmen or foresters'.

Locally we find Bushcomb Lane and Bushcomb Wood, both derived from Old English *cumb* and describing 'the valley of the Bishop of Worcester'.

The earliest pub signs were simply a sheaf of barley tied to a stripped tree trunk, allowing travellers to see that refreshment was available at this place. Such were referred to as ale stakes and thus the pub sign effectively pre-dates pub names. This also shows why so many trees form pub names, including here the Apple Tree Inn.

WOOLASTON

Domesday's Odelaweston is the only early record. The name refers to 'the farmstead or *tun* of a man called Wulflaf'. The local is the Netherend Inn, which takes a local place name meaning 'the lower place'.

Locally we find Wyvern Pond, the site of 'the double ford'; and Knight's Farm, the home of Mary Knight in 1784.

WOOTTON ST MARY

A name derived from Old English *wudu-tun* 'the farmstead in or by a wood', the parish church is dedicated to St Mary.

Early records show Cole Bridge takes its name from Old English *culfre*, thus the name describes the '(place where) doves abound by the bridge'. What was once 'Ine's enclosure' is now known as Innsworth; while Paygrove Farm occupies the place which began life as 'Paega's copse'.

WORMINGTON

Similar to the previous name this is from a Saxon personal name and Old English *ing-tun* and refers to 'the farmstead associated with a man called Wyrma'. The only early listing of note is Domesday's Wermetune.

WOTTON UNDER EDGE

Recorded as Wudutune in 940 and Vutune in 1086 this name comes from Old English *wudu-tun* and 'the farmstead in or by a wood'. The addition is a reference to its position under the escarpment of the Cotswold Hills.

Bear Street took the name of the Bear public house; Church Street is the lane leading to the church of St Mary's; and Haw Street leads to Hawpark Farm, itself meaning 'the enclosure park'; and Lisleway Hill describes 'the little road'. Golden Knoll could refer to its apparent colour in bright sunlight or even the name of the hill being 'the Golda hill'.

Sinwell means the '(place at) the seven springs'; Wimley Hill comes from 'Winebald's woodland clearing'; and Wortley is from Old English *wyrt-leah* or 'the woodland clearing used for growing vegetables'. Tiles or shingles were used for roofing as an alternative to thatching, places where these were quarried and/or stored would often be relected in the name – as is the case with the names of Tyley Bottom, Tyley Knoll and Tyley Wood.

The Cotswolds built its prosperity on the wool trade, hence the name of the Fleece Inn.

WYCK RISSINGTON

Listed as Risendvne in 1086 and Wikeresinden in 1236, this name comes from Old English *hrisen-dun* and means 'the hill overgrown with brushwood'. In later years the addition Old English *wic* suggested a 'dairy farm'.

The name of Double Dole is an interesting field name. Old English *dal* means 'to share', thus this is understood as 'the double-size shared field'.

WYE

One of the major tributaries of the Severn it is found as Waege in 956, Waia in 1086, Waie in 1086, and Wye in 1340; it is known in Welsh as the Gwy. This comes from the pre-Welsh *weg* and is related to Latin *veho*, both coming from the ancient root of *uegh* suggesting 'running water' or possibly 'travelling water' hence moving water and/or a way to travel.

WYND BROOK

Recorded as Wendebrok in 1496 and joining the Glynch Brook at Redmarley D'Abitot, this is a Celtic river name related to Welsh *gwyn* meaning 'white'.

The church at Wotton Under Edge

Chapter Twenty-Three

Y

YANWORTH

A name recorded as Janeworth in 1050 and Teneurde in 1086, may seem rather different from the modern form which is also why the meaning is uncertain. There can be no doubt this is Old English and may show a Saxon personal name with worth and give 'Gaen's enclosure'. However the region here has forever been associated with sheep farming and it is tempting to suggest this is *ean-worth* or 'the enclosure for the rearing of lambs' even if the etymology does not particularly favour either definition.

Locally Dean Grove is derived from Old English *denu*, meaning 'valley'.

YATE

Recorded as Geate in 779 and Giete in 1086, this is from Old English *geat* and describes it as 'the place at the gate or gap'. To the Saxons a gate was a 'way in' (or out) and not the barrier across the road but the road itself.

The name of Brinsham Farm comes from 'Brynu's water meadow', while Bays Quag combines the family name of Baye with an abbreviation of 'quagmire'.

The sign at Yarnworth

Common
Place Name Elements

Element	Origin	Meaning
ac	Old English	oak tree
banke	Old Scandinavian	bank, hill slope
bearu	Old English	grove, wood
bekkr	Old Scandinavian	stream
berg	Old Scandinavian	hill
birce	Old English	birch, tree
brad	Old English	broad
broc	Old English	brook, stream
brycg	Old English	bridge
burh	Old English	fortified place
burna	Old English	stream
by	Old Scandinavian	farmstead
ceap	Old English	market
ceaster	Old English	Roman stronghold
cirice	Old English	church
clif	Old English	cliff, slope
cocc	Old English	woodcock
cot	Old English	cottage
cumb	Old English	valley
cweorn	Old English	queorn
cyning	Old English	king
dael	Old English	valley
dalr	Old Scandinavian	valley
denu	Old English	valley
draeg	Old English	portage
dun	Old English	hill
ea	Old English	river
east	Old English	east
ecg	Old English	edge
eg	Old English	island
eorl	Old English	nobleman
eowestre	Old English	fold for sheep

fald	Old English	animal enclosure
feld	Old English	open land
ford	Old English	river crossing
ful	Old English	foul, dirty
geard	Old English	yard
geat	Old English	gap, pass
haeg	Old English	enclosure
haeth	Old English	heath
haga	Old English	hedged enclosure
halh	Old English	nook of land
ham	Old English	homestead
hamm	Old English	river meadow
heah	Old English	high, chief
hlaw	Old English	tumulus, mound
hoh	Old English	hill spur
hop	Old English	enclosed valley
hrycg	Old English	ridge
hwaete	Old English	wheat
hwit	Old English	white
hyll	Old English	hill
lacu	Old English	stream, water course
lang	Old English	long
langr	Old Scandinavian	long
leah	Old English	woodland clearing
lytel	Old English	little
meos	Old English	moss
mere	Old English	lake
middel	Old English	middle
mor	Old English	moorland
myln	Old English	mill
niwe	Old English	new
north	Old English	north
ofer	Old English	bank, ridge
pol	Old English	pool, pond
preost	Old English	priest
ruh	Old English	rough
salh	Old English	willow
sceaga	Old English	small wood, copse
sceap	Old English	sheep
stan	Old English	stone, boundary stone
steinn	Old Scandinavian	stone, boundary stone
stapol	Old English	post, pillar
stoc	Old English	secondary or special settlement
stocc	Old English	stump, log
stow	Old English	assembly or holy place
straet	Old English	Roman road
suth	Old English	south
thorp	Old Scandinavian	outlying farmstead

treow	Old English	tree, post
tun	Old English	farmstead
wald	Old English	woodland, forest
wella	Old English	spring, stream
west	Old English	west
wic	Old English	specialised, usually dairy farm
withig	Old English	willow tree
worth	Old English	an enclosure
wudu	Old English	wood

Bibliography

Street Names of Cirencester by Richard Tomkins

The Place Names of Gloucestershire Parts I, II, III and IV by A. H. Smith

Campden: A New History by A. Warmington

Tewkesbury by Anthea Jones

Berkeley — An Appreciation of its Buildings and History

Notes and Recollections of Stroud by Paul Hawkins Fisher

Berkeley: A Town in the Marshes by David Tandy

Alderton, Gloucestershire — edited by Ian S. Parkin

Bourton on the Water by Harry Clifford

The City of Gloucester by Jill Voyce

A History of Cheltenham by Gwen Hart

Chapters in Newent's History by Newent Local History Society

An Historical Gazeteer of Cheltenham by James Hodson

Also available from Amberley Publishing

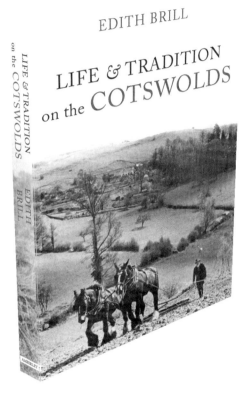

Life & Tradition on the Cotswolds
by Edith Brill

Price: £14.99
ISBN: 978-1-84868-036-4

Also available from Amberley Publishing

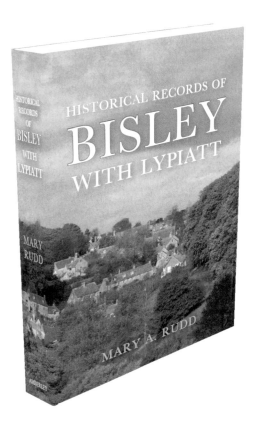

Historical Records of Bisley with Lypiatt
by Mary A. Rudd

Price: £15.99
ISBN: 978-1-84868-154-5

Available from all good bookshops or from our website
www.amberleybooks.com